Gifts of the Muse

Reframing the Debate About the Benefits of the Arts

Kevin F. McCarthy | Elizabeth H. Ondaatje
Laura Zakaras | Arthur Brooks

Commissioned by

The Wallace Foundation

Supporting ideas.
Sharing solutions.
Expanding opportunities.

RAND RESEARCH IN THE ARTS

The research in this report was commissioned by The Wallace Foundation.

Library of Congress Cataloging-in-Publication Data

Gifts of the muse : reframing the debate about the benefits of the arts / Kevin F. McCarthy
 ... [et al.].
 p. cm.
 "MG-218."
 Includes bibliographical references.
 ISBN 0-8330-3694-7 (pbk.)
 1. Government aid to the arts. 2. Arts and society. I. McCarthy, Kevin F., 1945–

NX720.G54 2004
701—dc22
 2004021806

The RAND Corporation is a nonprofit research organization providing objective analysis and effective solutions that address the challenges facing the public and private sectors around the world. RAND's publications do not necessarily reflect the opinions of its research clients and sponsors.

RAND® is a registered trademark.

Published 2004 by the RAND Corporation
1776 Main Street, P.O. Box 2138, Santa Monica, CA 90407-2138
1200 South Hayes Street, Arlington, VA 22202-5050
201 North Craig Street, Suite 202, Pittsburgh, PA 15213-1516
RAND URL: http://www.rand.org/
To order RAND documents or to obtain additional information, contact
Distribution Services: Telephone: (310) 451-7002;
Fax: (310) 451-6915; Email: order@rand.org

Preface

Understanding the benefits of the arts is central to the discussion and design of policies affecting the arts. This study addresses the widely perceived need to articulate the private and public benefits of involvement in the arts. The findings are intended to engage the arts community and the public in a new dialogue about the value of the arts, to stimulate further research, and to help public and private policymakers reach informed decisions.

Recent policy debates about the arts—their role in society, how they should be funded, whether they are thriving or suffering—have been hampered by limitations in available data and the absence of a developed body of rigorous and independent research on the arts. Over the last several years, the RAND Corporation has been building a body of research on the arts to help inform public policy. In a series of reports on the performing arts, the media arts, and the visual arts, RAND researchers have been describing what is known—and not known—about the ecology of the arts, including recent trends in public involvement, numbers and types of arts organizations, sources and levels of financial support, and numbers and employment circumstances of artists working in different fields. RAND researchers have also examined how to build participation in the arts and whether partnerships between arts organizations and schools in California's Los Angeles School District are working effectively. In addition, ongoing research is being conducted to analyze innovative practices that state arts agencies across the country have adopted to encourage greater local participation in the arts.

This study is one in a series of publications on research in the arts conducted within RAND Enterprise Analysis, a division of the RAND Corporation. It was made possible by a grant from The Wallace Foundation, which seeks to support and share effective ideas and practices that expand learning and enrichment opportunities for all people. The Foundation's three current objectives are to strengthen education leadership in ways that improve student achievement, to improve out-of-school learning opportunities, and to expand participation in arts and culture.

Other RAND Books on the Arts

A New Framework for Building Participation in the Arts (2001)
Kevin F. McCarthy and Kimberly Jinnett

The Performing Arts in a New Era (2001)
Kevin F. McCarthy, Arthur Brooks, Julia Lowell, and Laura Zakaras

From Celluloid to Cyberspace: The Media Arts and the Changing Arts World (2002)
Kevin F. McCarthy and Elizabeth H. Ondaatje

A Portrait of the Visual Arts: Meeting the Challenges of a New Era (forthcoming)
Kevin F. McCarthy, Elizabeth H. Ondaatje, Arthur Brooks, and Andras Szanto

State Arts Agencies, 1965–2003: Whose Interests to Serve? (2004)
Julia Lowell

Arts Education Partnerships: Lessons Learned from One School District's Experience (2004)
Melissa K. Rowe, Laura Werber Castaneda, Tessa Kaganoff, and Abby Robyn

Contents

Figures

Summary

Current arguments for private and public investment in the arts emphasize the potential of the arts for serving broad social and economic goals. This emphasis is a fairly recent phenomenon. As late as the 1960s and 1970s, the value of the arts was still a given for the American public. By the early 1990s, however, the social and political pressures that culminated in what became known as the "culture wars" put pressure on arts advocates to articulate the public value of the arts. Their response was to emphasize the *instrumental* benefits of the arts: They said the arts promote important, measurable benefits, such as economic growth and student learning, and thus are of value to all Americans, not just those involved in the arts.

Such benefits are instrumental in that the arts are viewed as a means of achieving broad social and economic goals that have nothing to do with art per se. Policy advocates acknowledge that these are not the sole benefits stemming from the arts, that the arts also "enrich people's lives." But the main argument downplays these other, *intrinsic* benefits in aligning itself with an increasingly output-oriented, quantitative approach to public sector management. And underlying the argument is the belief that there is a clear distinction between private benefits, which accrue to individuals, and public benefits, which accrue to society as a whole.

Some arts advocates and researchers have expressed skepticism about the validity of arguments for the arts' instrumental benefits, and there is a general awareness that these arguments ignore the intrinsic benefits the arts provide to individuals and the public. So far, however, little analysis has been conducted that would help inform public discourse about these issues.

Study Purpose and Approach

The goal of the study described here was to improve the current understanding of the arts' full range of effects in order to inform public debate and policy. The study entailed reviewing all benefits associated with the arts, analyzing how they may be created, and examining how they accrue to individuals and the public through different forms of arts participation.

The basis of our study was an extensive review of published sources of several kinds. First, we reviewed the evidence for the instrumental benefits of the arts. Second, we reviewed conceptual theories from multiple disciplines we thought might provide insights about how such effects are generated, a subject largely ignored by empirical studies of the arts' instrumental benefits. Third, we reviewed the literature on the intrinsic effects of the arts, including works of aesthetics, philosophy, and art criticism. And finally, we reviewed the literature on participation in the arts to help us identify factors that give individuals access to the arts and the benefits they provide. This report synthesizes the findings from these sources and proposes a new way of thinking about the benefits of the arts.

The view we propose is broader than the current view. It incorporates both intrinsic and instrumental benefits and distinguishes among the ways they affect the public welfare. This framework acknowledges that the arts can have both private and public value, but also draws distinctions between benefits on the basis of whether they are primarily of private benefit, primarily of public benefit, or a combination of the two.

Figure S.1 illustrates the framework, showing instrumental benefits on top and intrinsic benefits on the bottom, both arranged along a continuum from private to public. On the private end of the scale are benefits *primarily* of value to individuals. On the public end are benefits *primarily* of value to the public—that is, to communities of people or to society as a whole. And in the middle are benefits that both enhance individuals' personal lives and have a desirable spillover effect on the public sphere.

We used this framework to examine both instrumental and intrinsic benefits in more detail, and we use it in this report to present our findings. In the process, we argue for an understanding of the benefits of arts involvement that recognizes not only the contribution that both intrinsic and instrumental benefits make to the public welfare, but also the central role intrinsic benefits play in generating *all* benefits deriving from the arts, and the importance of developing policies to ensure that the benefits of the arts are realized by greater numbers of Americans.

The Case for Instrumental Benefits

This report categorizes and summarizes the instrumental benefits claimed in the empirical studies:

- **Cognitive.** Studies of cognitive benefits focus on the development of learning skills and academic performance in school-aged youth. These benefits fall into three major categories: improved academic performance and test scores; im-

Figure S.1
Framework for Understanding the Benefits of the Arts

Instrumental benefits

Improved test scores	Improved self-efficacy, learning skills, health	Development of social capital
		Economic growth

Private benefits | **Private benefits with public spillover** | **Public benefits**

Captivation	Expanded capacity for empathy	Creation of social bonds
Pleasure	Cognitive growth	Expression of communal meaning

Intrinsic benefits

RAND *MG218-S.1*

proved basic skills, such as reading and mathematical skills and the capacity for creative thinking; and improved attitudes and skills that promote the learning process itself, particularly the ability to learn how to learn.

- **Attitudinal and behavioral.** The literature on attitudinal and behavioral benefits also focuses on the young. Three types of benefits are discussed in this literature: development of attitudes (e.g., self-discipline, self-efficacy) and behaviors (e.g., more frequent school attendance, reduced dropout rates) that improve school performance; development of more-general life skills (e.g., understanding the consequences of one's behavior, working in teams); and development of pro-social attitudes and behaviors among "at risk" youth (e.g., building social bonds, improving self-image).

- **Health.** The literature on the therapeutic effects of the arts can be classified by types of effects and populations studied. These include improved mental and physical health, particularly among the elderly and those who exhibit signs of dementia from Alzheimer's disease; improved health for patients with specific health problems (e.g., premature babies, the mentally and physically handicapped, patients with Parkinson's disease, those suffering from acute pain and depression); reduced stress and improved performance for caregivers; and reduced anxiety for patients facing surgery, childbirth, or dental procedures.

- **Social.** The literature on community-level social benefits focuses on two general categories: those benefits that promote social interaction among community members, create a sense of community identity, and help build social capital;

and those that build a community's organizational capacity through both the development of skills, infrastructures, leaders and other assets, and the more general process of people organizing and getting involved in civic institutions and volunteer associations.

- **Economic.** There are three principal categories of economic benefits: direct benefits (i.e., those that result from the arts as an economic activity and thus are a source of employment, tax revenue, and spending); indirect benefits (e.g., attraction of individuals and firms to locations where the arts are available); and a variety of "public-good" benefits (e.g., the availability of the arts, the ability to have the arts available for the next generation, and the contribution the arts make to a community's quality of life).

The report also provides an assessment of the quality of this body of research. We found that a small number of studies provide strong evidence for cognitive, attitudinal, and behavioral benefits, but the available studies of health and social benefits were limited in terms of data and methodology, particularly the lack of longitudinal data. We found the research on economic effects to be the most advanced, but more analysis of the relative effects of spending on the arts versus other forms of spending is needed.

Overall, we found that most of the empirical research on instrumental benefits suffers from a number of conceptual and methodological limitations:

- **Weaknesses in empirical methods.** Many studies are based on weak methodological and analytical techniques and, as a result, have been subject to considerable criticism. For example, many of these studies do no more than establish correlations between arts involvement and the presence of certain effects in the study subjects. They do not demonstrate that arts experiences caused the effects.
- **Absence of specificity.** There is a lack of critical specifics about such issues as how the claimed benefits are produced, how they relate to different types of arts experiences, and under what circumstances and for which populations they are most likely to occur. Without these specifics, it is difficult to judge how much confidence to place in the findings and how to generalize from the empirical results.
- **Failure to consider opportunity costs.** The fact that the benefits claimed can all be produced in other ways is ignored. Cognitive benefits can be produced by better education (such as providing more-effective reading and mathematics courses), just as economic benefits can be generated by other types of social investment (such as a new sports stadium or transportation infrastructure). An argument based entirely on the instrumental effects of the arts runs the risk of being discredited if other activities are more effective at generating the same effects or if policy priorities shift. Because the literature on instrumental benefits

fails to consider the comparative advantages of the arts in producing instrumental effects, it is vulnerable to challenge on these grounds.

To address the second weakness—lack of specificity—we explored how effective different types of arts experiences may be in creating specific benefits. For example, we broke arts education into four types of arts experiences: an arts-rich school environment, art used as a learning tool, art incorporated into non-arts classes (such as history), and direct instruction in the arts. This approach highlights the special advantages that hands-on involvement in the arts can bring; it also suggests the types of effects that might be expected from the different forms of exposure, as well as why some of these effects may be more significant and long-lasting than others. One of the key insights from this analysis is that the most important instrumental benefits require sustained involvement in the arts.

The Missing Element: Intrinsic Benefits

People are drawn to the arts not for their instrumental effects, but because the arts can provide them with meaning and with a distinctive type of pleasure and emotional stimulation. We contend not only that these intrinsic effects are satisfying in themselves, but that many of them can lead to the development of individual capacities and community cohesiveness that are of benefit to the public sphere.

We think that art can best be understood as a communicative cycle in which the artist draws upon two unusual gifts—a capacity for vivid personal experience of the world, and a capacity to express that experience through a particular artistic medium. A work of art is "a bit of 'frozen' potential communication" (Taylor, 1989, p. 526) that can be received only through direct personal experience of it. Unlike most communication, which takes place through discourse, art communicates through felt experience, and it is the personal, subjective response to a work of art that imparts intrinsic benefits.

We challenge the widely held view that intrinsic benefits are purely of value to the individual, however. We contend that some intrinsic benefits are largely of private value, others are of value to the individual *and* have valuable public spillover effects, and still others are largely of value to society as a whole (see Figure S.1, above). We place the following intrinsic benefits at the primarily private end of the value range:

- **Captivation.** The initial response of rapt absorption, or captivation, to a work of art can briefly but powerfully move the individual away from habitual, everyday reality and into a state of focused attention. This reaction to a work of art can

connect people more deeply to the world and open them to new ways of seeing and experiencing the world.

- **Pleasure.** The artist provides individuals with an imaginative experience that is often a more intense, revealing, and meaningful version of actual experience. Such an experience can produce pleasure in the sense of deep satisfaction, a category that includes the satisfaction associated with works of art the individual finds deeply unsettling, disorienting, or tragic.

Intrinsic benefits in the middle range of private-to-public value have to do with the individual's capacity to perceive, feel, and interpret the world. The result of recurrent experiences, these benefits spill over into the public realm in the form of individuals who are more empathetic and more discriminating in their judgments of the world around them:

- **Expanded capacity for empathy.** The arts expand individuals' capacities for empathy by drawing them into the experiences of people vastly different from them and cultures vastly different from their own. These experiences give individuals new references that can make them more receptive to unfamiliar people, attitudes, and cultures.
- **Cognitive growth.** The intrinsic benefits described above all have cognitive dimensions. When individuals focus their attention on a work of art, they are "invited" to make sense of what is before them. Because meanings are embedded in the experience rather than explicitly stated, the individual can gain an entirely new perspective on the world and how he or she perceives it.

Finally, some intrinsic benefits fall at the public end of the scale. In this case, the benefits to the public arise from the collective effects that the arts have on individuals:

- **Creation of social bonds.** When people share the experience of works of art, either by discussing them or by communally experiencing them, one of the intrinsic benefits is the social bonds that are created. This benefit is different from the instrumental social benefits that the arts offer.
- **Expression of communal meanings.** Intrinsic benefits accrue to the public sphere when works of art convey what whole communities of people yearn to express. Examples of what can produce these benefits are art that commemorates events significant to a nation's history or a community's identity, art that provides a voice to communities the culture at large has largely ignored, and art that critiques the culture for the express purpose of changing people's views.

How Individuals Gain Access to the Benefits

A wide range of benefits can be gained from involvement in the arts, but we contend that many of them—and particularly those most often cited by arts advocates—are gained only through a process of sustained involvement. Three factors help explain how individuals become involved in the arts and thus gain access to the benefits the arts offer.

The gateway experiences that acquaint individuals with the arts constitute the first factor. Although these initial experiences can occur at any age, they appear to be the most conducive to future arts involvement if they happen when people are young (that is, of school age, particularly pre-teen). The second factor is the quality of the arts experience: Individuals whose experiences are fully engaging—emotionally, mentally, and sometimes socially—are the ones who continue to be involved in the arts. Continued involvement develops the competencies that change individual tastes and enrich subsequent arts experience. The third factor, which is the key difference between individuals who participate frequently in the arts and those who do so only occasionally, is the intrinsic worth of the arts experience to the individual. Those who continue to be involved seek arts experiences because they find them stimulating, uplifting, challenging—that is, intrinsically worthwhile—whereas those who participate in the arts infrequently tend to participate for extrinsic reasons (such as accompanying someone to an arts event). The model of the participation process that we developed not only highlights these points, but also suggests how to build involvement in, and therefore demand for, the arts.

Policy Implications and Recommendations

The study's key policy implication is that policy should be geared toward spreading the benefits of the arts by introducing greater numbers of Americans to engaging arts experiences. This focus requires that attention and resources be shifted away from supply of the arts and toward cultivation of demand. Such a demand-side approach will help build a market for the arts by developing the capacity of individuals to gain benefits from their arts experiences. Calls to broaden, diversify, and deepen participation in the arts are, of course, hardly novel, but efforts along these lines have so far been hampered by a lack of guiding principles. Our analysis of how individuals develop a life-long commitment to the arts suggests a variety of ways in which to promote this objective.

Based on our study, we recommend a number of steps the arts community might take to redirect its emphasis, shifting it toward the promotion of satisfying arts experiences:

- **Develop language for discussing intrinsic benefits.** The arts community will need to develop language to describe the various ways that the arts create benefits at both the private and the public level. The greatest challenge will be to bring the policy community to explicitly recognize the importance of intrinsic benefits. This will require an effort to raise awareness about the need to look beyond quantifiable results and examine qualitative issues.
- **Address the limitations of the research on instrumental benefits.** Since arts advocates are not likely to (and should not) abandon benefits arguments in making the case for the arts, it is important that they be more specific in how they make that case in order to develop the credibility of the arguments. Future research should take advantage of the theoretical and methodological insights available in the non-arts literature. Moreover, future research should not continue to be limited to instrumental benefits.
- **Promote early exposure to the arts.** Research has shown that early exposure is often key to developing life-long involvement in the arts. That exposure typically comes from arts education, community-based arts programs, and/or commercial entertainment. The most promising way to develop audiences for the arts would be to provide well-designed programs in the nation's schools. But this approach would require more funding, greater cooperation between educators and arts professionals, and the implementation of effective arts education programs that incorporate appreciation, discussion, and analysis of art works as well as creative production. Community-based arts programs, if well designed and executed, could also be an effective way to introduce youth to the arts, but they tend to be severely limited in resources. Another way to facilitate early arts involvement would be to tap into young people's involvement in the commercial arts. High schools, for example, might consider offering film classes that engage students in discussions of some of the best American and international films.
- **Create circumstances for rewarding arts experiences.** Arts organizations should consider it part of their responsibility to educate their audiences to appreciate the arts.

Most of the benefits of the arts come from individual experiences that are mentally and emotionally engaging, experiences that can be shared and deepened through reflection, conversations, and reading. The strategies we recommend for building arts involvement would help make these experiences accessible to greater numbers of Americans.

Acknowledgments

This report benefited from the thoughtful review of Bill Ivey, Director of The Curb Center for Art, Enterprise, and Public Policy at Vanderbilt University, and Steven J. Tepper, formerly of Princeton University and now at Vanderbilt. We also extend our thanks to several scholars who participated in a lively and insightful discussion of an earlier draft of this report: James Catterall (Professor of Urban Schooling, UCLA), Neil DeMarchi (Professor of Economics, Duke University), Jerrold Levinson (Professor of Philosophy, University of Maryland, College Park), and Michael O'Hare (Professor of Public Policy, University of California, Berkeley). A number of our RAND colleagues—Rebecca Collins, Julia Lowell, and James Quinlivan—also provided thoughtful responses to early drafts and joined the informal discussion with outside experts. Finally, we benefited from numerous helpful comments from Ann Stone, Evaluation Officer, Lee Mitgang, Director of Editorial Services, and many others at The Wallace Foundation. We are also grateful to The Wallace Foundation for sponsoring this study.

Research Assistants Jennifer Novak and Christine Schieber contributed to early phases of the research, and Lisa Lewis and Judy Rohloff provided critical research support. We are also grateful to Jeri O'Donnell, whose skillful editing added clarity to our arguments.

CHAPTER ONE

Introduction

Arguments for why the arts should be supported have undergone a dramatic shift since the mid-1960s, when the U. S. government first started funding the arts systematically. In the early years of public funding, from the late 1960s through the 1970s (a period in which nonprofit organizations of all shapes and sizes spread rapidly from the main urban centers into communities across the country), the American public hardly questioned the benefits of the arts. Public funding was intended to create a cultural sector befitting a nation of America's economic and political power. There were, of course, charged political debates about how public funding should be allocated—Are major institutions that offer European high arts getting too much of the money? Are cultural communities outside that tradition not getting enough?—but the benefits of the arts themselves were rarely debated.

In the early 1990s, however, a combination of factors put arts supporters on the defensive. A recession intensified budget battles at the state and federal level, there was growing skepticism about government programs coupled with a movement toward greater accountability, and works of art produced by publicly funded artists were being loudly condemned by those who saw them as offensive. The so-called culture wars made arts supporters realize that they needed to build a case for the value of the arts that would effectively appeal to the American public and its legislative representatives.

That case has since evolved into an argument that the arts produce benefits—economic growth, education, and pro-social behavior—that all Americans (not just those involved in the arts) recognize as being of value. To support this argument, arts advocates have borrowed from the language of the social sciences and the broader policy debate to show how the arts benefit society. The arts are said to improve test scores and self-esteem among the young. They are said to be an antidote to myriad social problems, such as involvement in gangs and drugs. They are said to be good for business and a stimulus to the tourist industry and thus to local economies. They are even said to be a mechanism for urban revitalization. The argument, in short, seeks to justify the arts in terms of their *instrumental* benefits to society.

There is nothing new about arguments based on instrumental benefits—in the 19th century, for example, the arts were promoted as a means of civilizing and assimilating immigrants.[1] But these arguments now appear more pervasive than ever. They view the arts as a means of achieving broad economic and social goals, such as education, crime reduction, and community development. In other words, investment in culture is justified in terms of culture's ability to promote broad public policy objectives. Some of the arguments do acknowledge that the arts have more than just instrumental benefits, that they also "enrich people's lives." But the acknowledgment is subordinated to the main argument, which aligns with an increasingly output-oriented, quantitative approach to public sector management. The underlying assumption is that the *intrinsic* benefits of the arts promote people's personal goals and are therefore not within the public policy focus on benefits to society as a whole.

Many arts supporters are uncomfortable with instrumental arguments as justification for the arts because they know that some of the claims are unsubstantiated or exaggerated and that they fail to capture the unique value of the arts. Yet these supporters recognize that many of the people who authorize public spending on the arts—and often private funding as well—will only respond if the arguments are cast in terms of the broad social problems that sit at the top of their agendas.

The purpose of our study was to examine the merits of the instrumental arguments within the context of a much broader analysis of the full range of benefits offered by the arts. Our goal was to provide a better understanding of these benefits in order to inform public debate and policy. We set out to do the following: identify these benefits, analyze how they may be created, examine how they accrue to both individuals and communities through different forms of arts participation, address the relative public value of different benefits, and explore the policy implications of our findings. We know of no other systematic study of these issues.

Study Approach

We began by conducting an extensive review of published sources of several kinds: (1) evidence for the instrumental benefits of the arts; (2) conceptual theories from multiple disciplines we felt might provide insights about how such effects are generated—a subject largely ignored by empirical studies of the benefits of the arts; (3) literature on the intrinsic effects of the arts, which included works of aesthetics, philosophy, and art criticism; and (4) literature on arts participation, which was used to

[1] For a history of such instrumental arguments, see Stephen Benedict's *Public Money and the Muse: Essays on Government Funding of the Arts* (1991). See also Joli Jensen's *Is Art Good for Us? Beliefs About High Culture in American Life* (2002).

help us identify the factors that give individuals access to the arts and the benefits they provide. We describe these literature reviews, respectively, in Chapters Two through Five and elaborate on conceptual theories in the Appendix.

In the course of this wide-ranging reading, we realized that to consider the full range of potential benefits of the arts, we would have to step back from the terms of the current debate, which are colored by the need to justify public spending on the arts in the face of other pressing societal demands. To do so, we developed a framework that distinguishes among benefits along two different dimensions: whether they are of the instrumental type or are intrinsic to the arts experience, and how they contribute to the public welfare. As we have explained, *instrumental* benefits are indirect outcomes of arts experiences. They are called instrumental because the arts experience is only a *means* to achieving benefits in non-arts areas. In fact, the arts are only one of a number of ways these benefits can be achieved. *Intrinsic* benefits, in contrast, are inherent in the arts experience itself and are valued for themselves rather than as a means to something else. The second dimension of our framework recognizes that the arts can contribute to the public welfare in a variety of ways. This dimension sorts the benefits of the arts along a continuum that ranges from those that are primarily personal, or private, on one end to those that are primarily public on the other end. In between are benefits that enhance individual lives and also have spillover effects that benefit the public sphere.

Figure 1.1 illustrates this framework and offers examples showing each category of benefits. Instrumental benefits are along the top, intrinsic benefits are along the bottom, and both types are arranged along a spectrum from private value to public value. On the private end of the scale (left side) are benefits primarily valuable to individuals. On the public end (right side) are benefits that accrue primarily to the public, or to communities. (These benefits can even improve the lives of community members who have no direct experience of the arts.) In the middle range are benefits that enhance personal lives and also have a desirable spillover to the public welfare.

We recognize that there are no definitive lines of demarcation along the scale of private to public, but this integrative way of framing the benefits of the arts has several advantages:

- It helped us map the full range of benefits, including intrinsic benefits inherent in the arts experience. People are drawn to the arts not for their instrumental effects, but because encountering a work of art can be a rewarding experience—it can give individuals pleasure and emotional stimulation and meaning. These intrinsic benefits are the fundamental layer of effects leading to many of the instrumental benefits that have dominated the public debate and the recent research agenda.

Figure 1.1
Framework for Understanding the Benefits of the Arts

Instrumental benefits

| Improved test scores | Improved self-efficacy, learning skills, health | Development of social capital |
| | | Economic growth |

Private benefits | *Private benefits with public spillover* | *Public benefits*

| Captivation | Expanded capacity for empathy | Creation of social bonds |
| Pleasure | Cognitive growth | Expression of communal meaning |

Intrinsic benefits

RAND *MG218-1.1*

- It helped us explore the links among types of benefits and identify the similarities and differences in the processes by which they are accrued. Our findings suggest that the process for most instrumental benefits differs from that for intrinsic benefits.
- It explicitly recognizes that arts benefits—both instrumental and intrinsic—can have both private and public value. For too long, discussions of the benefits of the arts have been limited by the assumption of a complete separation between private benefits, which are isolated into a realm of their own, and instrumental benefits, which improve the public sphere. Moreover, such discussions have failed to consider the variety of ways in which intrinsic benefits can contribute to the public welfare.

Another important aspect of our study is that we focused on the arts *experience*, rather than the work of art, as a key to understanding the value of the arts in both private and public terms. We did not directly address distinctions among art forms or the organizational ecology of the arts with its nonprofit, commercial, and volunteer art sectors—although we do recognize the importance of these distinctions and that all of these sectors provide arts experience capable of generating benefits that contribute to the public welfare. We looked at the characteristics that strong arts experiences have in common—whether those experiences are of a painting, a poem, a film, a dance, or a musical performance; and whether they take place in a museum, a living

room, a classroom, or a movie theater. The critical element we sought was the emotional and mental engagement of the individual in the experience.

Finally, our study was a conceptual exploration that synthesized empirical and theoretical research relevant to our inquiry. We did not evaluate individual studies of arts benefits; we relied on evaluations conducted by others. We did not conduct our own empirical work to test arts effects; we put together an overview of studies conducted by others, highlighting their strengths and weaknesses in the aggregate. We also did not do an in-depth review of research in other fields; we drew on insights from key texts in multiple fields that we found useful, sacrificing depth for breadth. We are aware of the risks of this approach, but we felt it was the only way to develop a conceptual framework in an area that falls at the crossroads of so many different disciplines. Our ultimate goal is to influence the way in which the benefits of the arts are understood and discussed, and to improve the way in which policies to promote these benefits are designed.

Report Overview

The next chapter describes the literature on the instrumental benefits of the arts. For each category of instrumental benefits, we provide an overview of the empirical literature, including benefits claimed, populations studied, types of arts participation in question, and research methods used. Also included is an evaluation of the main limitations of the empirical literature and the questions it leaves unanswered. Chapter Three addresses some of the gaps in the empirical research by examining more closely the ways in which some of the claimed instrumental benefits of arts experiences may be created. This discussion distinguishes among different types of arts participation in schools and in communities and draws upon research on behavioral and community change to suggest effects likely to result from different types of arts participation. Although this discussion is speculative, it is meant to sensitize both researchers and arts advocates to the need for more specificity in their claims about instrumental benefits. A summary of the theoretical literature referred to in Chapter Three (which includes works on cognitive and behavioral development, social psychology, community development, and economics) is presented in the Appendix.

Chapter Four examines a missing element in both the research and the public discourse on the arts: the intrinsic benefits of arts experiences. Drawing on studies in fields such as philosophy, aesthetics, and art criticism, we discuss our contention that art is a unique form of communication, one capable of creating intrinsic benefits that enhance the lives of individuals and often contribute to the public welfare as well. Chapter Five describes how individuals can gain access to these benefits—that is, how they become initially involved in the arts, how that involvement can deepen and

change over time, and how that process provides benefits. Chapter Six then highlights our key findings and discusses their policy implications.

Instrumental Benefits: What Research Tells Us—And What It Does Not

Supporters of the instrumental argument for the arts base their case on findings from the growing body of empirical evidence on the benefits of the arts. These studies initially focused on the economic benefits of the arts, but they now cover a much wider range of instrumental benefits, including cognitive, attitudinal and behavioral, and health benefits at the individual level, and social and economic benefits at the community level. As a first step in making our argument for a different approach to the benefits of the arts, we review here the evidence used to support the instrumental argument.

Despite some major problems with this body of literature, the studies do offer evidence suggesting that the arts can produce public benefits at both the individual and the community level. However, noteworthy weaknesses—most particularly, the nature of the methodologies used, the selective nature of the populations studied, and what is often a failure to specify how arts participation generates the effects claimed (both in terms of the underlying theory and how the effects relate to specific forms of participation)—constitute holes in the evidence. And perhaps the most important problem of all is that the literature and the advocates who use it fail both to acknowledge that these private and public effects can be generated in other ways and to discuss why the arts may be well suited to achieving these ends. As a result, skeptics are likely to remain unconvinced.

The purpose of this review is not to analyze individual studies, but to provide a high-level overview of the evidence used to support the instrumental argument for the arts. We begin with the cognitive, attitudinal and behavioral, and health benefits claimed in the research, then move to the social and economic benefits. In each case, we describe the benefits claimed, the form of participation identified, and the types of analytical methods used. In addition, for individual-level benefits, we describe the populations that have been studied for this category of benefits and whether the evidence allows us to generalize to other population groups. Finally, we summarize the strengths and weaknesses of the evidence.

Cognitive Benefits

Types of Benefits and Populations Studied

Studies of cognitive benefits focus on the development of learning skills and academic performance in school-aged youth.[1] The benefits of arts involvement examined in these studies fall into three major categories:

- Improved academic performance, such as grades and test scores (most particularly SAT scores).
- Improved basic skills, such as reading and mathematical skills and the capacity for creative thinking.
- Improved attitudes and skills that promote the learning process itself, particularly the ability to learn how to learn, as well as increases in school attendance, self-discipline, self-efficacy, and interest in school.[2]

As this list shows, these studies focus on improved grades or enhanced learning skills. They do not look at what Eisner (2000) has described as the range of ways in which the arts broaden and deepen an individual's understanding of the world. These particular cognitive benefits are among the intrinsic benefits of the arts and, as such, are discussed later, in Chapter Four.

Types of Arts Involvement

Consistent with their emphasis on school-aged youth, studies of cognitive benefits typically focus on arts participation through formal education, which takes several forms:

- The arts as an aid to the development of traditional academic skills, such as asking students who are learning to read to act out what they have read rather than simply repeating it verbally.[3]

[1] Useful summaries of the various studies of cognitive benefits can be found in Richard Deasy's *Critical Links: Learning in the Arts and Student Academic and Social Development* (2002); Edward Fiske's *Champions of Change: The Impact of the Arts on Learning* (1999); Nancy Welch's *Schools, Communities, and the Arts: A Research Compendium* (1995); Judith Weitz's *Coming Up Taller* (1996); the Arts Education Partnership's *Gaining the Arts Advantage: Lessons from School Districts That Value Arts Education* (1999); and the fall/winter issue of the *Journal of Aesthetic Education* (2000).

[2] Several of the measures in this category are also used in studies of the attitudinal and behavioral benefits of the arts. Overlaps such as this reflect the close relationships among benefits and the fact that studies with different focuses often use the same or similar measures.

[3] Another example is the "Mozart Effect," a frequently observed relationship between the playing of certain kinds of music (Mozart in the initial studies, but more-varied selections in subsequent studies) and students' scores on various spatial reasoning tests. Although various studies have measured a statistically significant difference in students' scores on these tests, the effects appear to be small, short lived, and of questionable substantive significance.

- Art works (e.g., paintings, music, and literature) integrated into non-arts courses (e.g., history and social studies) to improve students' understanding of those course subjects.
- The arts as a subject in their own right. This kinds of arts education can take one of two forms: arts appreciation (e.g., the history of art or an introduction to music), and training in performing or creating art in various disciplines—that is, "hands-on" training.[4] Hands-on training of this sort has been underscored in the literature as a particularly useful way to generate educational benefits.[5]

By and large, studies of cognitive benefits differentiate between levels of participation in terms of the number of years of study or classes taken. They also usually indicate whether instruction was in arts training or was incorporated in non-arts subjects, and if the latter, which art forms were taught (drama and music are the two most often taught).[6]

Most studies of cognitive benefits focus on in-school education programs. Some, however, have examined community-based art programs, and these have found that positive cognitive benefits are not limited to in-school programs (Heath, 1999). Although most analysts recognize that some students take private lessons outside school or participate in community-based activities, we know of no studies that have examined whether this factor has any effect on cognitive outcomes. Some studies have examined the important role parents play in getting funding for arts education (particularly school-based) programs.

Methods

The studies use widely varying methodologies to identify cognitive benefits. Some provide purely theoretical discussions, using individual case studies as illustrations; others provide correlational analysis or an empirical approach with formal experimental designs. Because the studies vary so much in approach and rigor, they have drawn strong criticism. Take, for example, the meta-analysis that Winner and Hetland (2000) conducted of cognitive benefit studies published during the prior ten years. They found that only 32 of the 1,135 studies they reviewed met the quasi-

[4] This distinction between arts appreciation and hands-on participation is consistent with the National Assessment of Educational Performance (NAEP) standards for assessing educational achievement in the arts, which provide separate guidelines for performing, creating, and appreciating ("reviewing" in NAEP's terminology).

[5] As we discuss in the next chapter, the key to this finding seems to be that there are different ways of learning (some people learn well by reading, others by acting the material out, etc.) and that different approaches to teaching reflect these differences. Whereas the typical school-based approach is to teach students concepts in the abstract, hands-on, or practical, teaching methods focus on specific practical problems and then introduce concepts as they apply to specific practical applications.

[6] Catterall (1997) notes that art and music are the most frequent disciplines taught in the first eight years of schooling, and that drama and music are more frequently taught in the higher grades.

experimental design criteria that they assert is necessary for testing significant effects.[7] Indeed, their work led them to assert that empirical evidence of significant cognitive benefits is largely lacking. They also criticized these studies for their general failure to provide an analytical framework for explaining benefits—i.e., for not describing the mechanisms that cause the cognitive benefits or the way in which specific types of arts participation (called the *treatment variable* in the social sciences) trigger those mechanisms.

One of the central methodological problems with the studies on cognitive benefits is the failure to distinguish between correlations among their outcome variables (benefits) and control variables (arts education experiences) and causality. The fact that the two types of measures are related does not necessarily imply that the former causes the latter. This problem is particularly important in studies asserting that certain cognitive benefits—especially, higher test scores—are caused by arts education rather than by the much greater likelihood that students from higher socioeconomic backgrounds have had arts education. A particularly noteworthy exception to this pattern is provided by the work of Catterall (1998, 1999). He demonstrates not only that the effects of education hold true within *as well as* between socioeconomic groups, but that these effects appear to increase as students with lower socioeconomic status gain more exposure to the arts. Heath's work (1999) on community-based arts programs in which the students are generally from low-income communities also finds that arts education effects are evident within that population.

Attitudinal and Behavioral Benefits

Types of Benefits and Populations Studied

Although the literature on attitudinal and behavioral benefits sometimes treats changes in attitudes and behavior separately, we discuss them together here. The theoretical literature we reviewed on these benefits emphasized that the process of individual behavioral change proceeds from beliefs to attitudes, then moves to intentions and finally to behavior. Attitudinal change is best examined as a step in the dynamics that lead to behavioral change.

Like the studies of cognitive benefits, attitudinal and behavioral studies of arts effects focus on school-aged youth.[8] They often concentrate on young students, and

[7] To be selected, a study had to be a data-based study that examined instruction in the arts in general (rather than a specific artistic discipline), had to include non-arts academic achievement as an outcome, and had to use a control group—in essence a quasi-experimental design.

[8] Indeed, many of the studies that examine cognitive benefits also include studies of behavioral and attitudinal effects. See, for example, Richard Deasy's *Critical Links: Learning in the Arts and Student Academic and Social Development* (2002) and Judith Weitz's *Coming Up Taller* (1996). Also see RAND reports on prosocial effects: McArthur and Law's *The Arts and Prosocial Impact Study: A Review of Current Programs and Literature* (1996);

a substantial subset of them focus on young people whose prior behavior or background has led them to be considered at risk for problem behavior. The benefits discussed in this literature can be grouped in terms of three types of effects:

- The development of attitudes and behaviors that promote school performance. These include motivation to do well in school, self-discipline, self-efficacy (i.e., the belief in one's ability to perform a variety of tasks), and specific behaviors such as school attendance and reduced dropout rates.
- The development of more-general life skills, such as critical thinking, self-discipline, understanding that one's behavior has consequences, self-efficacy, self-criticism, and teamwork—all skills that promote success in life as well as school.
- The development of pro-social attitudes and behaviors among at-risk youth. These include developing social bonds and working with mentors who can inculcate norms of what constitutes acceptable or desirable behavior (such as avoiding drug or alcohol use), as well as improving one's self-image, self-regulation, and tolerance.

Types of Arts Involvement

As was true for the studies of cognitive benefits, studies of attitudinal and behavioral benefits concentrate on exposure to the arts through educational programs. Intensity of participation is often measured in terms of types of arts education courses, years of training, and the characteristics of this exposure, such as what disciplines, what mode of participation (hands-on or appreciation), and, for individuals in other institutional settings, the nature of the arts program.

Many of these studies conclude that hands-on participation—especially in the form of public performance or presenting—is particularly beneficial. Of special note is the work of Heath (1999), which not only demonstrates the importance of hands-on participation to a variety of attitudinal and behavioral benefits, but also suggests reasons why this form of participation may be so effective. She notes, for example, that students given the responsibility for creating their own performances have a much greater opportunity to develop the variety of skills needed to plan a performance, to engage in discussions about performance with peers and adult mentors and receive feedback from them, to learn how to collaborate with others (including how to accept constructive criticism), and to develop a sense of self-efficacy. Some of the benefits are tied specifically to the planning and practice required to prepare for the performance, activities that depend on teamwork and trust. The studies also ac-

and Ann Stone et al.'s *The Arts and Prosocial Impact Study: An Examination of Best Practices* (1997) and *The Arts and Prosocial Impact Study: Program Characteristics and Prosocial Effects* (1999).

knowledge that the benefits of performing can be gained whether the activity takes place in school or in the community.

Methods

As was true for the cognitive studies, the studies of attitudinal and behavioral benefits employ a range of methods. Indeed, attitudinal and behavioral outcomes are often included in studies of cognitive benefits (Heath, 1999; Catterall, 1999). Studies of more-general behavioral and attitudinal benefits, especially for at-risk youth, are often conducted in institutional settings. In this case, even if the studies use more-rigorous analytical methods (e.g., experimental or quasi-experimental designs), they are typically limited to subjects in a particular treatment program and therefore have to be characterized as case studies. As a result, it is difficult to generalize their results to other populations and contexts.

Health Benefits

Types of Benefits and Populations Studied

The literature on the therapeutic effects of the arts is not nearly as well developed as the literature on the benefits already described.[9] It can be classified by the types of effects and populations studied:

- Improved quality of life, including mental and physical health, particularly among the elderly and those who exhibit signs of dementia from Alzheimer's.
- Improved health for a variety of patients—such as premature babies, the mentally and physically handicapped, patients with Parkinson's disease, and those suffering from acute pain and depression.
- Reduced stress and improved performance for caregivers.
- Reduced anxiety for patients facing surgery, childbirth, or dental procedures.

Most of the quality-of-life studies were conducted among the elderly (as the list above shows), but theses studies' findings about benefits are assumed to be true for anyone. In contrast, the health-related studies included not just various types of patients, but also caregivers. And they also included patients preparing for a variety of

[9] The strongest studies of therapeutic effects—Verghese et al., 2003; Marwick, 2000; and Wilson et al., 2002—appeared in the *Journal of the American Medical Association* and the *New England Journal of Medicine* and concern the delayed onset and reduced risk of dementia from Alzheimer's disease. A 1993 article by Heber in *Perspectives in Psychiatric Care* raises important issues about whether the techniques applied in "dance movement therapy" are actually derived from dance techniques or are simply more-general physical movement. A critique of the literature is presented in James and Johnson, 1997.

medical treatments. Although there is some overlap in the types of benefits examined in the two types of studies, there is also variation. The quality-of-life studies stress measures of good mental and physical health and concentrate on the ability of arts involvement to delay the loss of mental acuity. The health-related studies focus more on how the use of arts in therapy aids both the caregiver (by relieving stress or improving performance) and the patient (by relieving the anxiety that procedures such as surgery can engender or helping those with particular physical disabilities).

Types of Arts Involvement

There are two types of arts involvement (typically described as "arts therapies" in this literature): hands-on creative activity (most particularly, dance and theater) and appreciation (typically, listening to music or looking at pictures). The specific forms these activities take vary depending on the therapy involved:

- Music therapy consists of either listening to music to induce calmness and relaxation or singing (often called vocal therapy) to retrain vocal control or to elicit response and alertness.
- Dance therapy typically involves rhythmic movement to music to foster physical or emotional rehabilitation.
- Art therapy entails using the visual arts to facilitate communication and diagnosis (most typically as a complement to psychoanalysis).
- Drama therapy involves creative expression in dramatic form or psychodrama in which patients role-play in real-life or structured situations.

Methods

As Heber (1993) has noted, it is not clear how many of these therapies actually involve an "arts" treatment. In dance therapy, for example, there is typically movement in response to music, but this is not necessarily dancing. These studies are usually clinical studies of specific populations. They most often appear in medical practitioner or gerontological journals, the articles generally reporting correlations between the use of or presence of art in the health care environment and its generally positive effects on healing and general well-being. While some of these studies use quantitative outcome measures, most of them use qualitative measures of the various benefits and often rely on subjects' self-reports. Few specifics are offered about the combination of populations, ailments, and arts applications that can be most positively affected by the use of arts in health care.

Community-Level Social Benefits

Types of Benefits

The literature on the social benefits of the arts at the community level has emerged only in the last few years and has not yet developed connections to established theory in the social sciences.[10] The benefits it examines fall into two general categories:

- Promotion of social interaction among community members, creating a sense of community identity and helping to build social capital at the community level.
- Empowerment of communities to organize for collective action.

Some of the studies that fall into the first general category focus on the way the arts help connect members of a community together. They describe how the arts can create a public realm that provides opportunities for direct social contact and thus for establishing links and building bonds among the members of a community (Lowe, 2000; Griffiths, 1993; Stern, 2000). These bonds help promote trust within a community and thus help build social capital—defined as the network of norms of trust and reciprocity and the benefits that arise from it (Putnam, 2000). Arts events and activities can give people a feeling of belonging (gained through joining a group or becoming involved with local arts organizations) and can reinforce an individual's connection to the community by giving public expression to the values and traditions of that community and sustaining its cultural heritage (Fromm, 1955; Lowe, 2000; Griffiths, 1993; Stern, 2000). (As we discuss in Chapter Four, some of these benefits to communities are intrinsic benefits inherent to the arts experience.) In addition, by fostering bridges among diverse social groups, the arts can promote tolerance and an appreciation of new cultures (Wali, Severson, and Longoni, 2002; Stern, 2000). Finally, the literature in this category discusses how the arts can generate community pride and prestige (see, for example, Jackson, 1998). [11]

In the second category are studies maintaining that the arts can enhance conditions conducive to building a community's organizational capacity. The enhancement comes through the development of local arts groups and leaders, through the promotion of cooperation among arts and non-arts groups, and through the more general process of people organizing and getting involved in civic institutions and volunteer associations—structural assets that are essential for community mobilization and revitalization (Wali, Severson, and Longoni, 2002; Stern, 2000). Studies of

[10] Mario-Rosario Jackson (1998) has criticized this literature for not being rooted in theories about social impacts.

[11] As part of its National Neighborhood Indicators Project, the Urban Institute did exploratory work to measure the existence and impact of arts and culture, broadly defined, on community life. See http://www.urban.org/nnip/acip.html.

these effects span many disciplines, including economics, political science, anthropology, sociology, and psychology, and employ a wide variety of methodologies, such as case studies, theoretical works, and ethnographies, as well as the more familiar empirical approaches. These studies relate to a diverse set of community populations, including individuals drawn together by common interests (e.g., a particular art form) or affiliation (e.g., association with a community arts group), social and ethnic groups, neighborhoods, and whole cities (as well as combinations of the various units).[12]

Types of Arts Involvement

The studies differ substantially in terms of the types of arts involvement examined. Indeed, they often do not delineate specific types of arts participation, referring instead to "involvement in arts and culture" or "arts participation," and sometimes maintain that the social benefits a local community derives from the arts can also reach those not directly involved in the arts. The more empirical studies, however, often concern the "informal arts" (as opposed to arts in the nonprofit or commercial sector), such as hands-on participation in a community arts project (Wali, Severson, and Longoni, 2002; Lowe, 2000). The focus in these studies is on the process of community members coming together to pursue shared goals—how this gives them a feeling of connectedness and belonging, develops trust, and creates organizational skills and a habit of civic involvement. Much less attention is paid to how these social benefits accrue to those who attend arts events, participate as appreciators or audience members, or are involved in the arts as stewards. Moreover, given the empirical literature's focus on informal arts, it is unclear whether the benefits apply to arts participation in the nonprofit or commercial sectors, as well as whether certain community characteristics are important in mediating these processes.

Methods

The bulk of this literature is based on case studies. Some of these look at groups of participants in specific arts activities or organizations (e.g., mural project, choral groups), whereas others examine specific projects, such as construction of a performing arts center in a city. Such studies typically focus on one form of participation (e.g., community arts) and one type of benefit (e.g., group cohesion or encour-

[12] *Community* refers to many different entities, including communities of interest, ethnicity, geography, and past association. Community can be felt from within (e.g., feeding the poor), defined from outside (e.g., a town), or both (alumni of a particular college). One of our concerns with the literature was the variety of definitions used. For our purposes, we focused on what was relevant for social benefits, which meant we emphasized social ties, cohesion, developing a group identity, feelings of belonging, etc. We were also interested in the practical application of the power of the group, which involves structural issues relating to community (e.g., leaders, organizations, lines delineating what is and is not in the community). In short, we were concerned with the capacity of individuals to overcome the barriers to collective action—to forming a community, feeling like a community, and acting like a community.

agement of civic pride). A smaller portion of the literature on social benefits collects data using surveys and other data collection techniques to identify the number of arts organizations and level of arts activities in a given community. A final group of these studies is developing new concepts and methods for assessing how the arts impact the quality of life in communities. This group is small and still in its infancy, but it may eventually provide some promising methods.

Though growing rapidly in quality and quantity, the body of empirical literature on the benefits of the arts to communities is limited by both data and methodology. Given the long-term processes involved in building a sense of community or effecting community change, the lack of longitudinal data is a severe limitation. But longitudinal studies can require substantial investments with little immediate return. Moreover, the task of isolating the impact of the arts from that of all the other factors that can generate social benefits is especially difficult. The time that elapses between the initial arts activity (e.g., attendance) and the desired social outcome of social capital is often so great, and the number of other factors so large, that researchers can at best measure intermediate outputs from the activity (e.g., interactions among strangers or becoming a subscriber) that might eventually produce social capital.

Economic Benefits

Types of Benefits

Studies of the economic benefits of the arts, which were the first to examine the arts' instrumental effects, are far more numerous than all the other studies we have described. There are several reasons for this.

First, since few people will dispute that something which promotes economic growth has clear public benefits, an economic argument for the arts is a particularly useful starting place for convincing those who are not already supporters of the arts to become such. Second, in contrast to the academic fields for the other categories of instrumental benefits, the academic field of cultural economics is already a well-developed discipline with a variety of theories that can be used to explain why and how involvement in the arts can generate economic effects. Indeed, several different economic approaches are available for testing for and explaining both direct and indirect economic benefits of the arts.[13]

[13] There are literally dozens of studies on the economic benefits of the arts. The following works provide but a sampling: J. Myerscough's *The Economic Importance of the Arts in Great Britain* (1988); the National Assembly of State Arts Agencies' *Measuring Your Arts Economy: Twelve Questions and Answers About Economic Impact Studies* (1997); Arthur Bianchini's "Remaking European Cities: The Role of Cultural Policies" (1993); Arthur Brooks and Roland Kushner's *Cultural Policy and Urban Development* (2001); Greg Richards's "The European Cultural Capital Event: Strategic Weapon in the Cultural Arms Race?" (2000); Allen J. Whitt's "Mozart in the Metropolis: The Arts Coalition and the Urban Growth Machine" (1987); Ashish Arora et al.'s "Human Capital, Quality of Place and Location" (2000); and Richard Florida's "Competing in the Age of Talent" (2000).

There are three principal categories of economic benefits:

- Direct economic benefits are those that result from the arts as an economic activity and thus as a source of employment, tax revenues, and spending for local communities (variously defined in the literature as cities and metropolitan areas). These benefits fall into three different groups: employment for those who work in arts industries (both artists and related arts workers), in industries that directly supply arts organizations with goods and services, and in industries that benefit from providing services (e.g., food, lodging, parking) to arts consumers; revenues for governments who collect income, sales, and property taxes on incomes, purchases, and real property of arts and related industries and their employees and consumers;[14] and the increases in overall economic activity (spending and employment) that the arts industry adds to a local market through the "multiplier effect"—the additional spending generated by direct expenditures on the arts.
- Indirect economic benefits are those that result when the arts attract individuals and firms to locations where the arts are available. These benefits hinge on the attraction the arts offer to particular classes of workers (skilled) and firms (high value-added), an attraction that strengthens the local economy and promotes economic development (Florida, 2002).
- "Public-good" benefits, which benefit both those who are involved in the arts and those who are not, include a wide range of primarily nonfinancial benefits. *Existence benefits*, for example, is the name for the satisfaction individuals derive from knowing the arts exist and are being preserved (much like a park or wildlife refuge) even if they themselves do not participate. *Option value* is the benefit people derive from knowing the arts exist and that they thus can participate in the future (whether they do or not). *Bequest value* is the satisfaction individuals derive from preserving the arts for the future enjoyment of their children and grandchildren. Finally, individuals value the arts because the arts can contribute to the general education and edification of the population and thus help produce a happier and more productive population.

Methods

Unlike the studies of the arts' other instrumental benefits, analyses of the arts' economic benefits routinely employ empirical data to measure the size of the effects. Generally, these studies are conducted in local market areas (typically urban rather than rural markets), and the methodologies used vary depending on the category of benefits. Studies of direct economic benefits, for example, typically begin by mea-

[14] To the extent that many arts organizations are nonprofit, property taxes are less important since the property of nonprofits is exempt from taxation.

suring direct employment in and spending for the arts and then use some form of input-output analysis (which measures the connections among industries) to generate estimates of multiplier effects.

The methods used in studies of indirect benefits include surveys to determine the preferences of different population groups for the arts (and the reported preferences of firms for particular classes of workers), and estimates of the travel costs different groups pay to attend the arts. Public-good benefits, which because they are nonfinancial are inherently difficult to measure, are often given a dollar value via a technique called contingent valuation, which asks individuals how much they would be willing to pay in taxes to enjoy these benefits, or via hedonic approaches that estimate how proximity to the arts affects housing values (an indicator of the desirability of the arts to the population).[15]

Despite its reliance on the empirical approach and the existence of well-specified theories to explain effects, the economic literature has been subject to much criticism. First, although the benefits can be defined conceptually, some of them, such as public-good and indirect benefits, are inherently difficult to measure, which means that the estimates reported in the literature may be considerably overstated. Second, most of these studies have been conducted in major urban areas and thus have excluded both smaller cities and nonmetropolitan areas. This second criticism may be playing a particularly important role in the estimates of multiplier effects, since the concentration on large cities and exclusion of the other two areas may mean that the experiences of tourists—who constitute a larger fraction of arts consumers in large cities, and who must pay for food, lodging, and other services while visiting—may be heavily influencing those estimates.

And, finally, these studies receive criticism because most of them do not consider the relative effects of spending on the arts versus other forms of consumption—that is, they fail to consider the opportunity costs of arts spending. Some economists dispute the validity of the multipliers used in economic studies because they assume that spending on the arts represents a net addition to a local economy rather than simply a substitute for other types of spending. At issue is whether investments in the arts sector, such as a new performing arts center, should be deducted from the additional spending that such an investment generates or whether the gross addition to total arts spending is the appropriate measure of the economic benefit. Seaman (2000), for example, asserts that spending on the arts merely substitutes for what would otherwise be spending on other goods and services. As a result, he and others have argued that it is more appropriate to compare gross direct spending and

[15] Hedonic approaches essentially assess the contribution that various attributes of a housing unit and its location contribute to total housing value by regressing the value on those characteristics.

employment effects than to use multipliers that assume all net spending on the arts represents a direct addition to the economy.[16]

Evaluation of the Literature

As this review indicates, the studies documenting the instrumental benefits of the arts vary greatly in focus, methods used, and analytical rigor. That variety complicates any attempt to evaluate the literature and appraise the applicability of the underlying instrumental arguments. As we have suggested, the analytical methods used to document those effects are uneven. Winner and Hetland (2000) point out that most of the cognitive benefits studies fail to use rigorous analytical methods—that is, they fail to use experimental or quasi-experimental designs to test for effects. This problem raises questions about the validity of specific studies. However, as suggested by the title of Winner and Hetland's review, "Mute Those Claims: No Evidence (Yet) for a Causal Link Between Arts Study and Academic Achievement," this failure means not that the claimed effects are not present, but that they have yet to be empirically demonstrated. Indeed, more-rigorous studies, such as those by Catterall (1997, 1998, 1999) and Heath (1999), offer strong evidence for the presence of cognitive, attitudinal, and behavioral effects.

DiMaggio (2002) points out a more serious issue with respect to the benefits literature: The question is not whether the instrumental benefits exist, but what the specific nature of those effects is and in what circumstances the effects can be expected to occur. DiMaggio identifies three problems, which he calls *fallacies*, that are embedded in the cultural policy discourse on the benefits of the arts, all of which can be found to some degree in the studies we reviewed. The first of these, *the fallacy of treatment*, refers to the implicit assumption that all forms of arts participation produce homogenous effects—that is, that arts education, hands-on participation by youth and adults, community-based arts programs, and attendance at performances (in whatever sector) all have similar effects. Our review of the research suggests this is not the case. Heath's work (1999), for example, indicates that the process of planning and creating a performance creates benefits different from those of other forms of participation. Also, research on community arts programs, as we shall describe, suggests that this kind of activity may provide its own, distinctive benefits to the

[16] However, economic studies of the benefits of the arts are more sensitive to the opportunity cost critique than are studies in other disciplines. Indeed, there is some dispute among economists as to whether studies of direct economic benefits should focus on the gross effects of arts spending on a local economy or the net effects compared with other investments of funds. See, for example, Robert Baade's paper on the economic effect that the Staples Center (a sports and concert events venue) has had on the City of Los Angeles, California (Baade, 2004), and Bruce Seaman's paper comparing the economic impacts of arts and sports (Seaman, 2004).

community. There is no reason to assume that the same benefits can be derived from attendance at professional performances.

A second problem DiMaggio sees is the *fallacy of homogeneity*, which is his name for the assumption that the arts (even when appropriately specified) will have the same effects on different types of participants and in different types of communities. This is equivalent to assuming that the arts contribution to local economies will be the same regardless of the share that nonresidents contribute to local arts spending, or that arts education will have similar effects on the learning process of youth, regardless of their level of educational development.

DiMaggio's third problem, the *fallacy of the linearity of effects*, is the assumption that benefits are generated in direct proportion to the level of arts participation—that is, that benefits increase as a linear function of participation in the arts. This assumption may be valid in some circumstances—for example, the level of economic benefits may increase as a direct function of the amount spent on the arts in a local economy—but it is unlikely to be valid in all circumstances. For example, to the extent that community-level social benefits require the accumulation of a critical mass of local residents to become involved in the arts before social capital is formed within the community, the relationship between arts involvement and the generation of social capital will assume the form of increasing returns to scale. A similar pattern is likely in the case of certain cognitive and behavioral benefits at the individual level, to the extent that individual participants must acquire certain skills or be involved with the arts over sustained periods before the benefits can be realized. However, there may be circumstances—e.g., the existence value we described earlier, in our discussion of economic benefits—where at some point the addition of another arts organization in the community adds less benefit than the addition of earlier arts organizations did. Under these circumstances, there may be a relationship of diminishing marginal returns.

To these three problems we would add a fourth fundamental weakness of the research on instrumental benefits: the failure to examine the comparative advantage of the arts over other means of achieving the same effects. Cognitive benefits can, for example, be promoted by better schooling, social benefits by forms of community activity other than arts involvement, and economic benefits by public investments in alternatives to the arts.

In the next chapter, we address a number of these limitations.

Instrumental Benefits: Getting More Specific

As underscored in the last chapter, research on the instrumental benefits of the arts fails to specify the mechanisms by which arts participation creates specific benefits. It also fails to specify the circumstances in which benefits accrue, the populations most likely to benefit in such circumstances, and the level of arts involvement needed to generate benefits. To address these issues, we reviewed literature from a range of disciplines to learn what is known about how individuals and communities change and to explore the relevance of this knowledge to arts participation and its claimed effects. Readers interested in a detailed summary of the main theories gleaned from the literature should direct their attention to the Appendix.[1]

This chapter builds on the knowledge we gained in our literature review to provide more specificity about the circumstances likely to create instrumental benefits, and what types of benefits are likely to flow from specific circumstances. We acknowledge that this is an exploratory discussion designed to promote closer attention to the ways in which individuals and communities may change through arts involvement. In the process, we hope to encourage further empirical studies that test whether any of these suggested connections can be demonstrated.

As we did in the last chapter, we begin with individual benefits and move to community benefits.

Creating Benefits to Individuals

The arts are claimed to have cognitive, attitudinal, and behavioral benefits for children who are exposed to the arts in school. The treatment variable is typically arts education, which comes in a number of forms. We know of no studies that examine

[1] By and large, the empirical literature on arts benefits fails to connect with theories from other disciplines that might explain how different aspects of the arts experience can generate instrumental benefits. The notable exception to this pattern is the literature on the economic benefits of the arts.

whether these benefits accrue to adults involved in creating, appreciating, or supporting the arts.[2]

The emphasis on education and youth is understandable given the critical role that schools play as the primary environment in which children acquire both substantive knowledge and the critical skills that are the building blocks of both their educational development and the personal and social skills that are key to their success in school and, later, in their work and personal lives. Moreover, because formal education is primarily concentrated in these formative years, children and adolescents are the natural population for these studies. In addition, as the theoretical literature on learning emphasizes, the transition from early childhood to primary schooling marks the transition from intuitive learning (which is based on observation and entails developing a natural understanding of how things work) to rule-based, or scholastic, learning (which typically stresses the acquisition of literacies, concepts, and the disciplinary forms of school). This transition in styles of learning is often quite difficult for young people whose learning skills and styles are not well suited to the linguistic and logical/mathematical styles emphasized in schools.

Although the empirical studies analyze the benefits of arts education, they rarely define the kind of arts education their subjects have been involved in. Instead, they often describe arts education in terms of the number of years of arts training or courses taken. What we do here is select different forms of arts education—also called *treatments*—and explain why they are likely to create certain kinds of benefits. Then, where we can, we suggest which kinds of young people are likely to benefit the most in such circumstances. Note that benefits associated with a specific treatment are not necessarily exclusive to that treatment; it is conceivable that they could be gained through one or more of the other treatments as well. For example, an improved attitude toward the arts and school could reasonably be associated not only with an arts-rich environment (as it is in the discussion that follows), but also with the use of the arts as a pedagogical tool to help students learn.

The treatments we describe are as follows:

- An arts-rich school environment, which incorporates the arts throughout the school curriculum and/or offers students a range of extracurricular activities in the arts.
- Art used as a pedagogical tool to help students learn. Examples are the use of music while studying or performing a scene from a reading lesson.
- Art integrated into non-arts courses as a means of teaching non-arts subjects, such as history and social studies.

[2] Health benefits are not included in the discussion here because, as we noted earlier, in discussing the empirical literature, the literature on the health effects of the arts is not well developed and is basically atheoretical.

- Direct instruction in the arts, including both arts appreciation and courses that teach creative skills, such as choir, orchestra, or painting.

Arts-Rich School Environment and Associated Benefits

Schools differ not only in the types of arts education they offer as part of the academic curricula, but also in the extent to which the arts are part of the general school environment. Some schools provide an arts-rich environment by infusing the arts into the different subject areas, hanging art on the walls, putting on plays, etc.; others offer extracurricular activities in the arts (such as school bands, orchestras, drama clubs, choir, visual arts exhibits); and still others may do a combination of curricular and extracurricular arts enrichment. An arts-rich school environment is also one that acknowledges the value of such activities and provides recognition to student participation.

Schools with an arts-rich environment offer a variety of opportunities for students to develop positive attitudes toward the arts and toward school more generally. These benefits may be particularly important for students whose learning skills and styles are not well suited to academic success in a traditional academic setting, but they would accrue to other students as well. The kinds of benefits that could develop from an arts-rich school environment are as follows:

- **Improved attitudes toward arts and school.** As the theoretical literature on attitudinal and behavioral change emphasizes, an individual's attitudes (a critical determinant of his or her subsequent behavior) are typically influenced by a combination of experiences, associations, and positive reinforcement. Thus, involvement in school-based arts activities (as well as arts activities in the community or the home) can influence an individual's attitudes not only toward the arts, but also toward the institutions he or she associates with the arts experiences (in this case, school).
- **New role models, mentors.** The opportunities that students have to form associations with faculty advisors and teachers, who can serve as role models and mentors, as well as with peers who share their interests, can reinforce their attitudes both toward the arts (and other pro-social behavior) and toward school and other institutions (e.g., churches, community groups) that also can play a formative role for youth.
- **Growth in self-confidence and self-efficacy.** The opportunity to define success in school not simply in terms of the traditional school measures (such as grades and test scores in traditional academic classes), but also in terms of rewarding school-based arts experiences, inclusion in arts-focused social groups, and success in arts classes and activities provides an important way for students to develop self-confidence and a sense of being well integrated into the school environment.

Self-efficacy, which is the individual's perceived ability to accomplish a variety of tasks, is a particularly important concept in theoretical discussions of the causes of behavioral change. It has been identified in both the educational and the behavioral literature as key to successful learning and to pro-social behavior more generally (Bandura, 1977). Indeed, Zimmerman (1995) states that self-efficacy improves an individual's ability to learn in several ways: it increases confidence in one's ability to solve problems; it induces one to expect success and to attribute that success to oneself; it helps one cope with the stresses and frustrations inherent in the learning process; it leads one to engage in situations in which one is likely to succeed and to avoid situations in which one might fail.[3]

Arts Used as Pedagogical Tool and Associated Benefits

As we indicated above, the transition from early childhood to the primary school environment typically involves a transition from intuitive to rule-based learning. In the school environment, students are usually taught in terms of concepts and rules, and educators often expect students to regurgitate facts, concepts, and problems as they have been taught. As Gardner (1999) notes, this type of transition can sometimes produce disconnections for learners. For example, empirical analysis has shown that the transition from intuitive to scholastic learning often involves an apparent decline in language performance because of the irregular nature of English language usage.

The problems can be intensified by the fact that students have different styles of learning. Gardner (1999) notes that individuals use many different forms of intelligence in the learning process and that these capacities are much broader than the linguistic and logical/mathematical modes of learning emphasized in scholastic approaches. He identifies eight different types of intelligences: language, logical-mathematical, spatial, musical, naturalist, kinesthetic (using the body to solve problems or make things), interpersonal (understanding other individuals), and intrapersonal (understanding ourselves). Not only can all individuals learn in each of these different ways, but the relative strength of these different intelligences varies across individuals. Thus, the ways in which such intelligences are involved and combined to carry out different tasks and solve diverse problems will also differ. This diversity in learning styles makes the arts (and arts-related techniques) well suited for teaching traditional academic skills. Bransford (1979), for example, cites studies showing that when poor readers were taught to create image "pictures" of words they were hearing or to associate descriptions of individuals in a story with specific individuals they knew, they were better able to recall and understand what they had read. In other words, certain activities—visualizing, verbalizing, and so forth—have different impli-

[3] There is some debate within the social psychology literature about whether self-efficacy is restricted to a particular domain (e.g., a particular art form, such as dancing) or has a more general effect on the individual.

cations as distinct modes of acquiring new information, and individuals have different preferences and abilities for learning modes.

The strength of these effects, however, is unclear. Although the benefits of this use of the arts may be readily accessible to students regardless of their prior experience with the arts, the arts in this situation are really being used to place new information in a more familiar context (and thus as an aid in understanding the new information) rather than to transfer specific knowledge of the arts to a different context. This distinction is important, because the theoretical literature on cognition recognizes three different levels of comprehension: the ability to recall newly learned information, the ability to apply that information to a context similar to the one in which it was learned, and the ability to apply that information to a context very different from the one in which it was learned. This last form of comprehension (called *transfer*) is the highest level of understanding. Using the arts in the way we have just described corresponds not to this highest level, but only to the first and second levels.

Arts as a Means of Teaching Non-Arts Subjects

The literature on learning underscores that the learning process involves relating new information to existing bodies of knowledge. As Bransford (1979, p. 136) puts it, "To grasp the meaning of a thing, an event, or a situation, is to see it in relationship to other things." Integrating the arts into the teaching of the more traditional academic subjects builds on this insight, as well as on the recognition of different learning styles and forms of intelligence, to enrich students' understanding of other subjects. This type of arts education, as we stated earlier, is seen most frequently in history and social studies classes, where the use of art objects from a particular period or culture can help students gain a richer sense of the culture or period they are studying. Moreover, it can enrich their understanding of the art itself by placing it in a particular social, political, and historical context. In the literature, this use of the arts is typically described for middle or secondary schools, but it appears to be akin to the approach used in college art history classes, the major difference being that the emphasis in the earlier grades is on the academic subject rather than the art per se.

The magnitude of these effects—particularly the ability to transfer knowledge gained from the arts to non-arts subjects—is likely to depend on the individual student's level of familiarity with and knowledge of arts subjects. The theoretical literature on learning, for example, identifies a third form of learning in addition to the intuitive and scholastic forms. This third type, disciplinary learning, involves a minimum level of mastery of skills and concepts of a particular domain. It is this form of learning that is most likely to facilitate transfer between arts and non-arts subjects.

Thus, although this type of arts education can promote relatively immediate benefits, it is likely to have its largest effects on those who already have some grounding in the arts, something that requires time and prior experience.

Direct Instruction in the Arts and Associated Benefits

Direct instruction in the arts, which includes both arts appreciation courses and instruction on creating art, is likely to have different kinds of effects and to be most relevant to different kinds of students depending on the type of instruction the student receives.

Arts Appreciation. There is a glaring absence of discussion of arts appreciation courses, such as literature or music theory, and their effects on participants. It is not clear why researchers pay so little attention to such courses (perhaps because of the general indifference to the intrinsic benefits of arts experiences in the public discourse?), but it is nevertheless surprising given that the diversity of artistic forms and subject matter provides such a rich context within which to learn. Another reason may be that the empirical studies of the arts' instrumental benefits focus on younger children, who receive very little instruction in arts appreciation. For children of this age, historical and critical perspectives on the arts should be linked to hands-on instruction, since a young child can best absorb these concepts when they are linked to the problems the child is working through (Gardner, 1989).

Creation of Art. As already noted, training in creating, or "doing," art appears to be the most fruitful way of producing both educational and behavioral types of instrumental benefits. Part of the reason for this may be, as Gardner (1989) suggests, that the learning process involved in such training differs from the learning process more generally. Gardner notes, for example, that children's performance in most areas of development improves with age, but that children are able to develop surprisingly high levels of artistic competence in their early years. In addition, whereas perception and comprehension capacities develop in advance of production in other areas of learning, the reverse appears to be true in the arts. Finally, Gardner suggests that while there is typically a parallel in other areas of learning between children's levels of learning in related subjects, children display much greater differences in competence across different artistic disciplines (Gardner, 1989).

At the root of these differences may well be the fact, as suggested in Chapter Two, that "doing" is a particularly effective way of learning. Indeed, Gardner (1989) argues that unlike the traditional scholastic approach, in which concepts are taught independently of practical problems, hands-on training in a specific art form provides an opportunity to involve students directly in the arts and use that practical experience to introduce concepts typically taught independently in the schools. This is his reason for suggesting that historical and critical perspectives be introduced in the course of hands-on instruction. Gardner goes on to draw implications for educational practice more generally from the ways in which practical arts instruction is conducted. Specifically, he asserts that arts education should be carried out over significant periods of time and should allow ample time for feedback, discussion, and reflection.

These advantages of hands-on instruction build on several of the key theoretical concepts of learning already discussed. Because it involves an integrated and progressive approach to teaching both practical skills and concepts, hands-on training is well suited to the cumulative nature of the learning process, in which new pieces of information are integrated into existing bodies of knowledge. Similarly, because hands-on training involves a diverse set of skills or intelligences, it is well suited to adaptation to the diverse learning styles and skills of students. And hands-on training in the arts almost necessarily requires students to monitor their own learning process and to recognize how important feedback—the practice of demonstrating their ability to perform what they have been taught—is to their progress.

Theoretical research on learning stresses the importance of these two elements for becoming an effective learner. Monitoring one's own learning process requires individuals to develop specific criteria to guide a self-evaluation of that process—in other words, they must develop the ability to know when they understand what they learn. And feedback is key in this context. Both elements are essential to learning how to learn, which is perhaps the most important instrumental benefit of arts education.

In addition, "doing" art provides a particularly effective way to develop the personal skills that are critical not only to becoming an effective learner, but to behavioral change as well. As discussed in the Appendix, the ability to translate attitudes and intentions into behavior is tied to the development of such personal skills as the ability to understand the consequences of one's actions, the ability to plan to achieve a desired goal, and self-discipline and self-regulation. Heath's work (1999) suggests that the key mechanism here appears to be the degree of preparation for performing. Preparation for a successful performance requires self-discipline and planning, which, if they lead to success, will build an individual's perceived self-efficacy.

Moreover, Heath also notes that working with other students who share common interests and goals and with teachers who can serve both as role models and sources of feedback can provide students with the mentoring and reinforcement needed to develop and exercise these skills.

However, as this discussion has indicated, neither of these benefits is likely to be triggered by a single arts experience. Whether we are talking about learning how to learn or developing the personal skills instrumental in promoting behavioral change and educational success, sustained involvement in the arts education process is necessary.

Creating Benefits to Communities

Social Benefits

The Appendix presents a framework for understanding how social and economic benefits are linked to arts experiences. This framework also gives us a structure for describing how the arts contribute to communities. At the most basic level, the arts provide opportunities for people to come together through their attendance at arts events and classes, arts festivals, and arts fairs. Regular involvement in these arts activities can produce social solidarity and social cohesion through the creation of community symbols (e.g., neighborhood murals) and community identity. The arts can also offer opportunities for building social capital, since interest and involvement in the arts can lead people to participate in arts-based associations and organizations—for example, subscribing to community-based arts organizations, performing with arts-based groups such as choirs and neighborhood theaters, and volunteering with such groups or becoming a member of their boards.

The move from social capital to community organizing involves the development of both a sense of collective efficacy and skills in leadership and organization.[4] The way in which the arts facilitate these developmental processes is through the raising of funds for local arts projects or facilities, the running of arts organizations and community arts projects, and the advising of local arts groups. The arts can also help create linkages across different groups, thus developing intergroup cooperation and establishing partnerships.

Building a sense of community and developing a capacity for collective action require the kind of sustained involvement in multiple activities over time that is necessary for the creation of many of the individual-level benefits. However, unlike most individual benefits, these social benefits typically require what might be called same-group participation—that is, the same group of individuals (e.g., the same ten or fifty people, or subsets thereof) need to participate over time. Not all social benefits require same-group participation, but the more complex community benefits require that personal ties be created through ongoing collaboration.

The benefits will differ, however, depending on whether the community is involved in creating art, appreciating art, or promoting art, as we describe next.

Creating Art. Although one might think of artists as solitary, many ways of creating art involve groups of artists and can lead to social interactions among the same group of people. Taking an art class, rehearsing as a choir, painting *au plein air* at a

[4] It is important to note, however, that, as Bourdieu (1984) points out, the selective character of arts participation (which tends to be dominated by the well educated) can serve to differentiate between the affluent and others based on their stock of cultural capital. In addition, there is a philosophical debate about the role that the arts can play in building community. Some critics argue, for example, that public and corporate support for the arts leads to noncontroversial art, and they criticize such art for promoting social cohesion without addressing the structural conditions that cause some communities to be at a disadvantage.

regular time and place, choreographing with a dance troupe—all of these are examples of activities that regularly bring the same individuals together over a period of time, leading to the development of social bonds. Individuals develop a sense of community as they exchange favors (such as meeting to learn lines, loaning painting supplies); identify themselves with a cast, music ensemble, or choral group; and develop a sense of trust and expectations of reciprocity. Indeed, the primary purpose of certain types of creative activity—community art, for example—is to build a sense of community and create a social identity among the participants.

But is there something different and somehow better about the sense of community gained from creative activity as opposed to other group activities—competing on a sports team, attending religious services, joining a coffee klatch, etc.? As discussed in the next chapter, the communicative nature of the arts, the personal nature of creative expression, and the trust associated with revealing one's creativity to others may make joint arts activities particularly conducive to forging social bonds and bridges across social divides. Also, through the arts of ethnic traditions—such as classical Indian dance or Jamaican steel drums or Japanese *raku* ceramics—participants develop and maintain their cultural heritage, and they communicate their cultural identity to outsiders.[5] There is also a group phenomenon in which the individual feels that the power of the group somehow transcends or at least exceeds the sum of the individual parts. Choral group singers, dancers in a troupe, symphonic orchestra members, and members of a drum circle experience the group as producing something that overwhelms both the creators and the audience.

Appreciating Art. Arts appreciation is hardly mentioned in the literature on social benefits, but collective appreciation of art clearly has instrumental social benefits. The greatest social benefits are likely to arise among subscribers, lecture series participants, and students in arts appreciation classes, if the same individuals are brought together repeatedly. Although this regular assembling of people committed to the same activity is not unique to the arts (season ticket holders for spectator sports and followers of the NASCAR circuit come to mind), the arts are a form of shared passion that might engender a sense of community among frequent attendees of different social and economic backgrounds and occupational status, ethnicity and race, and age and geography. We return to this subject in the next chapter, when we discuss the public benefits we identify as intrinsic rather than instrumental.

Though group attendance is the most direct path from arts appreciation to realizing these social benefits, it is also possible that an individual could participate alone or as part of a small group and, by virtue of this experience, establish connections and bonds to others that would be realized subsequently. Book groups are a popular example of this. An individual typically reads the book alone and then meets

[5] Debates about maintaining the purity of the art versus appealing to the mainstream surround this form of minority-to-majority communication.

with others in a group. This act of meeting to discuss the work (and many other topics) can be a powerful source of social bonding.

Supporting the Arts. In many regards, participating in the arts as a supporter, or steward, is the most direct route to many of the social benefits described above. Coming together with other people committed to the same arts organization, supporting the same project or arts festival, starting up a new group—these all provide an ideal set of activities for building a sense of community and generating social capital. Stewardship can include volunteers, board members, patrons, public officials, and even audience members. Indeed, supporting the organization or its members may be an audience member's primary reason for attending.

Volunteers in the arts, working together toward a shared objective—whether the task is constructing sets, raising funds, giving tours, or stuffing envelopes—have the opportunity to develop ties and bonds and a commitment to the organization. Volunteering might also mean board membership. Indeed, board members often come to mind first when one considers the social benefits of the arts and the creation of social capital. The social contacts and networks associated with overseeing an arts organization are often both the contributions and the benefits of board service. Moreover, by participating in the life of an organization this way, board members may develop not only social capital, but also specific competencies (such as the ability to review accounting procedures, to hire executive directors, and to revise bylaws) that can be beneficial to other community organizations.

Even though they are perhaps the least direct types of stewards, donors and other arts patrons can accrue social benefits through a feeling of commitment and belonging to a particular arts organization or local community. Public officials may authorize taxpayer funds for an organization or a specific event, as well as provide a source of legitimacy. In any event, to the extent that such private and public contributions improve the organization's chances of survival, this form of participation helps maintain community organizations.

This brings us to the other category of social benefits: development of the capacity for collective action. In principle, all forms of participation can help develop this capacity, though the most effective one is likely to be stewardship for the types of competencies that are employed. Participating in the informal arts, as chronicled by Wali (2002), is one path of stewardship that can build both individual and community capacities. It may start with an individual creating some form of art and evolve into organizational activities, from identifying people who can organize others to mounting a successful play or project. The characteristics of the informal arts, such as accessibility to people of all types and skill levels and performance in public spaces (e.g., church basements, community centers, parks, schools), attract some people who have the least experience, ties, and resources. In many cases, these people become involved in organizing some aspect of the activity. Specific skills that participants in informal arts might acquire include the ability to run a rehearsal or meeting;

knowing how to allocate time and other resources; knowing how to obtain needed equipment, permits, and funds, and how to recruit new participants; and knowing how to arrange advertising for the event. These activities build social and leadership skills and involve people in the civic life of their communities.

It is clear that such skills and civic involvement can contribute to the collective capacity of communities to address their own problems. Stewards of the arts—from volunteers to board members to donors and public officials—contribute to democratic civic life. Stepping forward to help produce a local production, launching a fund-raising campaign, and securing rehearsal or studio space in a community center are some of the many ways that people who may be drawn into local art communities might develop management and organizational competencies, a sense of collective efficacy, and relationships within the community in aid of future undertakings. Putting on an arts festival, preparing one's own group to join in a community exhibition, or advocating to save funding for a local arts agency or organization would involve disparate groups coming together to work on a common event, possibly laying the groundwork for intergroup cooperation to face other community challenges. While such organizational capacities, intergroup cooperation, and linkages across communities can contribute a great deal to community revitalization, particularly where the arts may provide the one point of agreement among disparate interests,[6] expectations must be tempered by the realization that the cultural sector is one of many sectors that must work together over time.

Economic Benefits: Why They Are a Special Case

The theoretical literature we have described so far suggests that instrumental benefits are often tied to the process of sustained arts involvement rather than to any specific participation activity. Thus, the greater an individual's level of involvement with the arts, the more likely he or she is to realize various categories of benefits. This is not the case, however, with economic benefits. Rather than focusing on individual patterns of involvement with the arts over time, the economics literature emphasizes how individual participation in activities, when aggregated across individuals, can trigger a variety of economic benefits.

Consider, for example, the category of direct benefits (see discussion in Chapter Two). The literature on direct benefits emphasizes how individual consumer choices, when considered in the aggregate, build demand for the arts and thus, in turn, stimulate the growth of the local economy. In this context, an arts aficionado who attends ten performances a year is equivalent to ten casual participants who attend

[6] Strom's study (1999) of the development of a new performing arts facility in New Jersey provides an example of the arts as a unifying issue among citizens, developers, city officials, and arts advocates. However, building arts venues as a cornerstone of economic development has lately been criticized in the European literature (Bianchini, 1993; Belfiore, 2002; Merli, 2002).

one performance a year. Thus, from an economic perspective, the benefits of the arts are independent of the level of individual involvement. The literature on indirect benefits is similar in that it premises indirect benefits less on specific patterns of individual involvement (such as mode of participation or preferred discipline) than on the different socioeconomic characteristics of those who value the arts and those who do not.

Perhaps the clearest example of this difference between the economic and other approaches to instrumental benefits lies in the case of the public good. As discussed in Chapter Two, public-good benefits are specifically predicated on the value individuals attach to the benefits the arts may provide either to the individuals themselves or to others, but not on the individual's direct involvement in the arts. Thus, the existence, option, and bequest benefits are not realized through one's direct participation in the arts but, rather, through the arts being available in one's community. Moreover, the prestige value that a community can obtain from the arts is based on the benefits that the community as a whole realizes from the esteem in which the community is held because of the arts available in the local area.

Although the literature on cultural economics is unique in the degree to which it has applied economic theory to the arts per se, the mechanisms through which these benefits are conveyed (with the exception of the public-good benefits) are neither specific to the arts nor predicated on the special character of the arts. For example, the multiplier effect driving the direct economic benefits of the arts to local communities is essentially the same whether what is producing the effect is the arts or some other type of economic activity (high-technology industry, for instance). Similarly, the comparative advantage that an arts-rich environment provides for stimulating local economic development could also be provided by other types of local amenities (say, a pleasant climate or a location along a seashore). Finally, many of the public-good benefits that the arts can provide can be provided by other types of public goods (e.g., educational facilities).

Thus, although the theory within the cultural economics literature is better developed than the theories in other areas, the mechanisms that produce the benefits are in no way unique to the arts. This, of course, is one reason why critics of this literature focus on the opportunity cost issue—that is, the relative effectiveness of the arts versus other types of economic activity for generating economic benefits.

Despite the generic nature of the mechanisms presumed to generate economic benefits from arts participation, the cultural economics literature does not ignore the fact that some types of participation are more conducive to benefits than others. Research on direct benefits, for example, places considerably more importance on attending live arts performances and visiting visual arts museums and galleries than it does on hands-on participation because those who attend live performances or visit museums or galleries have to pay for those experiences, creating a flow of spending. Moreover, the magnitude of these multiplier effects ought to be larger in communi-

ties with more-established commercial and nonprofit sectors, since cash flows are likely to be greater in the commercial and large nonprofit sectors than in the community and volunteer sectors. Indeed, this possibility could help explain why communities with well-known arts institutions may get more return for their arts spending than communities without such institutions do.

In contrast, the indirect benefits of the arts are predicated on the attraction the arts hold for well-educated and talented people. The literature on this topic focuses exclusively on such individuals' desire to attend concerts and other performances and to visit galleries and museums, but that does not mean these individuals may not also be attracted to places where there are ample opportunities for hands-on participation in the arts (e.g., community theaters, ensembles). In addition, the importance that firms are presumed to place on sponsoring and supporting arts organizations suggests that stewardship is also conducive to promoting the indirect benefits.

Conclusions

So, what has our analysis taught us about the instrumental benefits of the arts? As Chapter Two described, we learned that many of the claims that have been made about the arts' instrumental benefits are unsubstantiated. But, also as described, we learned that the failure to demonstrate clear links between arts involvement and specific benefits lies in methodological problems. This chapter presents some exploratory analysis, the purpose being to help base the possibility of such effects on an understanding of how they may be occurring in specific circumstances with specific populations. While this exercise may not be conclusive, it does offer suggestive observations to guide future inquiries in this area. Most important, it suggests why some instrumental benefits are more likely to be created than others, and why some are more likely to have a significant and lasting impact than others. We summarize these observations next.

Individual-Level Benefits

- Some forms of arts education are more likely to produce benefits than others, an observation that suggests empirical studies must be more specific about the type of arts activities engaged in by their subjects. The strongest arts-involvement effects on young people are likely to come from direct involvement in the performing arts. This is one of the few areas in which empirical studies have successfully demonstrated benefits from specified arts involvement. The theoretical literature offers potential explanations for why these benefits are likely to be created in such circumstances.

- Using the arts to teach concepts in non-arts subjects may be particularly useful for students who have nontraditional learning styles, but these effects may not be particularly strong overall.
- Of the claimed cognitive effects of arts participation on children, the enhancement of learning skills is more likely to occur than is the enhancement of knowledge acquisition in non-arts subjects (such as the development of mathematical skills).
- Perhaps the most important insight gained from the theoretical literature is that the process of change in individuals and communities proceeds in stages, these stages build one upon another, and this process typically takes time and sustained involvement. All but the most ephemeral benefits—which are those that accrue from the use of the arts as a pedagogical tool (for such tasks as recalling new information) and the effect of Mozart's music on spatial reasoning—are likely to require sustained involvement in the arts. These effects are minor and short lived. The more important benefits, such as learning how to learn and developing the personal skills needed for behavioral change, will not be triggered by short-term arts involvement.

Community-Level Benefits

- Most types of arts involvement have a social dimension that is likely to create many of the benefits claimed, assuming that the activity brings together the same participants over an extended period of time. These activities can provide an important basis for building social capital and community identity.
- Volunteering, organizing an arts group, serving on a board, and other forms of stewardship are important ways to build community organizational capacity, identify and develop leaders, and engender a variety of skills needed for community action. These activities can also facilitate the cooperation between arts and non-arts groups that is essential for community organizing.
- Economic effects, which have received much attention from the research community and the policy community, are in a class by themselves because their existence does not depend on individual effects. Direct economic benefits are driven by market forces, and indirect effects that provide economic benefits to local communities are largely the same whether the activity that drives them is the arts or some other industry. The magnitude of these effects depends on the aggregate level of demand and thus, at least implicitly, on consumption levels in the local community. But unlike individual-level and social benefits, economic benefits do not depend on behavioral factors such as sustained involvement.

What is seldom acknowledged about these instrumental benefits is that they can be achieved through many kinds of activities other than the arts. We turn next to the intrinsic benefits that arise from the arts experience and are of value in and of themselves.

Intrinsic Benefits: The Missing Link

Our discussion so far has focused exclusively on the instrumental benefits of involvement in the arts, but these are neither the only nor the most important benefits that the arts offer. What draws people to the arts is not the hope that the experience will make them smarter or more self-disciplined. Instead, it is the expectation that encountering a work of art can be a rewarding experience, one that offers them pleasure and emotional stimulation and meaning. To discuss these intrinsic effects, we need to abandon the more objective view of the social scientist and focus on the personal, subjective response of the individual. In this chapter, we attempt to describe these effects, how they occur, and how they affect the public sphere.

As we explained in Chapter One, intrinsic benefits refer to effects inherent in the arts experience that add value to people's lives. Obvious examples are the sheer joy one can feel in response to a piece of music or to movements in dance or to a painting. Beyond these immediate effects, there are personal effects that develop with recurrent aesthetic experiences, such as growth in one's capacity to feel, perceive, and judge for oneself and growth in one's capacity to participate imaginatively in the lives of others and to empathize with others. And some works go beyond such personal effects, providing a common experience that draws people together and influences the way the community perceives itself, thereby creating intrinsic benefits that accrue to the public.[1]

Given the importance of intrinsic benefits, it is unfortunate that they have been so marginalized in both public discourse and research on the arts. One reason for this trend is the predominant use in policy analysis of the social science model that focuses on measurable outcomes. Intrinsic benefits of the arts are intangible and difficult to define. They lie beyond the traditional quantitative tools of the social sciences, and often beyond the language of common experience. Although many advocates of the arts believe intrinsic benefits are of primary importance, they are reluctant to in-

[1] It must be acknowledged that instead of using the term *benefits*, the literature on artistic experiences talks about values or effects that enrich, even transform, individual lives. In describing our study, we use the term *benefits* for consistency in referring to all of the arts' beneficial effects, bearing in mind that in speaking of intrinsic effects, the term tends to imply outcomes more separable from the experience than is the case here.

troduce them into the policy discussion because they do not believe such ideas will resonate with most legislators and policymakers. In competing for financial support from both government and private foundations, the arts community is expected to focus on tangible results that have broad political backing, such as improved educational performance and economic development.

Another reason why personal enrichment is given only passing attention in discussions of the effects of the arts is that the dominant tradition in Anglo-American aesthetics over the past century has emphasized that the experience of art is separate from ordinary experience and that the appreciation of art should be disinterested, insulated from life, and its own reward. "Art for art's sake" in its various forms has been profoundly influential, and although the intent was to insulate art from demands that it be useful, the unintended consequence has been to make art seem remote, esoteric, and removed from life.[2] In effect, the predominance of this aesthetic theory has inhibited research into the ways that arts experiences enhance ordinary life.[3]

Approach

It may seem surprising to shift to a sphere in which claims cannot be supported empirically after we have just critiqued the studies of instrumental benefits on the basis of flaws in their empirical approach. We know of no way to prove the points we make in this chapter, yet we believe in the importance of improving the understanding of this category of effects. Our discussion relies on the writings of many individuals who have contemplated the effects of the arts over the centuries, starting with Aristotle in the fourth century B.C. Our approach is to draw on these individuals' insights to reach an improved understanding of some specific issues:

- The nature of the arts experience.
- The range of intrinsic benefits and how they are created.
- The ways that personal benefits affect the public sphere.

[2] Richard Shusterman (2000) claims that "the underlying motive for such attempts to purify art from any functionality was not to denigrate it as worthlessly useless, but to place its worth apart from and above the realm of instrumental value" (p. 9). He bemoans the effects of this tradition, however, in which "art was . . . quarantined in an aesthetic domain essentially defined, after Kant, by its utter disinterestedness, by 'complete indifference' to 'the real existence' of things. This view not only belies the efforts of artists who sought to change the world by transforming our attitudes. It also encourages the practice and reception of art as something essentially purposeless and gratuitous" (p. 52).

[3] Other views have been gaining attention since the 1990s; see, for instance, Shusterman, 2000; Budd, 1995; Goldman, 1995; and Stecker, 1997.

We grounded our analysis in publications from several disciplines, including works of aesthetics and philosophy; literary, art, and film criticism; social and political philosophy; and artists' accounts of the creative process. We selected works that describe the intrinsic values of the arts experience, but we also included general accounts of the creative process, the nature of the work of art, and the nature of aesthetic experiences, our objective being to provide a better understanding of how the transmission of effects from artist to audience works. Based on key concepts in the aesthetics literature, we chose works of philosophy that address important aspects of the experience of art, such as the role of emotion or cognition in aesthetic judgment, the ways aesthetic experiences can shape an individual's moral understanding, and, likewise, how such experiences can help develop the sympathetic imagination so important in a democratic, pluralistic society. The works of criticism we selected were those that address the connection between art and life, the importance of public discourse about the arts, and the way individual experiences of a work of art are made intelligible to others.[4]

It should be acknowledged that the insights presented in this chapter all have their origins in other commentaries, but that the shape of this synthesis is our own. The process of deciding what to select, what to exclude, and how to relate insights of others was guided by our analysis of the connections among the ideas set out in so many different disciplines and contexts.

Art as a Communicative Experience

We begin by describing our model of the full cycle of artistic expression and appreciation. This model provided a context for our analysis of the aesthetic experience—that is, the direct encounter with a work of art that produces the intrinsic effects we wanted to identify and describe. Our model provides a hypothesis about the nature of the process by which art is created and enjoyed and helps us explain how certain effects are created during the experience of a work of art.

[4] We also looked for the best descriptions of the creative process, which, naturally, are written by artists themselves. As happens in all literature reviews, we followed leads from one text to another, and in the process found several useful studies by social psychologists about the way individuals learn from experience—including the experience of imaginative literature—and one fine work of political philosophy that examines the relationship between aesthetic judgment and personal freedom, Samuel Fleischacker's *A Third Concept of Liberty: Judgment and Freedom in Kant and Adam Smith* (1999). We found only one philosophical work that offers an extended account of the aesthetic experience, John Dewey's *Art as Experience* ([1934] 1980), a rich and insightful discussion to which we are heavily indebted. Other sources we found useful in writing this chapter are works by and about Kant; the writings of Romantics, such as Keats and Emerson; texts by modern literary critics who stand outside today's critical mainstream, such as Lionel Trilling's *The Liberal Imagination: Essays on Literature and Society* (1953), Wayne Booth's *The Company We Keep: An Ethics of Fiction* (1988), and Philip Fisher's *Wonder, the Rainbow, and the Aesthetics of Rare Experiences* (1998); and recent works of aesthetics that focus on why the arts are valuable (for example, Shusterman, 2000; Budd, 1995; Goldman, 1995; and Levinson, 1996).

"A work of art is . . . a bridge, however tenuous, between one mind and another."[5] This insight is a key to understanding the intrinsic effects of arts experiences. Art is a communicative experience, a bridge from artist to audience and a bridge linking individual beholders to one another. Figure 4.1 offers a notional illustration of how the communicative cycle works.

The first step in the cycle, artistic creation, is one of the most complex and mysterious activities of human consciousness. It is only partly intelligible, even to those who have experienced it directly. However, accounts of the process generally agree that the artist draws on the two different kinds of abilities shown in the top oval of Figure 4.1. The first is a highly developed capacity for vivid experiencing of the world (including one's inner, private world). The artist, painter, writer, or composer often starts with an experience that is a kind of discovery. This is what happened to Monet as a young man when he walked through the fields and suddenly saw them as a vibrant array of color, more various than he had ever seen before. Countless similar examples suggest that artists are able to experience the world in ways not obvious to most people. In Eudora Welty's terms, the artist has "a cultivated sensitivity for observing life, a capacity for receiving its impressions, a lonely, unremitting, unaided, unaidable vision" (Welty, 2002, p. 53).

Figure 4.1
Art as a Communicative Process

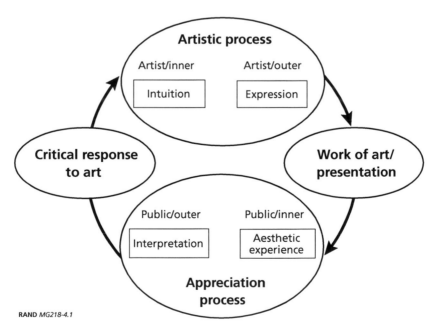

RAND *MG218-4.1*

[5] Andrew Harrison, quoted in Booth, 1988, p. 1.

The second capacity is the ability to express this unique experience through a particular medium. Joyce Cary, the Irish novelist, writes that the creative process is "a kind of translation, not from one language into another, but one state of existence into another, from the receptive into the creative, from the purely sensuous impression into the purely reflective and critical act" (Rader, 1961, p. 108). In the act of expression, the artist makes inner reality public and therefore communicable to others. The material he or she works with—whether language, image, sound, or movement—is not raw material but, rather, a public system of symbolic meaning developed and refined by generations of use and thus shaped by the society in which the artist develops. In working with the medium, the artist moves back and forth between his or her vision and the perspective of the imagined audience in a process of protracted labor. What is completed becomes an object in the physical world, which others can encounter and explore. Typically, the writer's labor is described in terms similar to those in T. S. Eliot's *The Four Quartets: East Coker*, 1943: "the intolerable wrestle/with words and meanings" (sec. 2).[6] The long-standing concept of art as skilled execution is illustrated in the *Oxford Dictionary* by quotations from John Stuart Mill, who writes that "art is an endeavor after perfection in execution," and from Matthew Arnold, who calls art "pure and flawless workmanship."

The work of art that results from this process of skilled execution is what Taylor calls "a bit of 'frozen' potential communication" (1989, p. 526) that stands apart from the artist, often speaking to audiences over long periods of time and great cultural distance. (We return to the subject of what and how art communicates in the next section.)

The next step in the cycle is the appreciation process. The effect of a work of art is felt immediately in the aesthetic experience, and that experience can have a continued effect when the individual reflects on it and shares his or her impressions with others, as suggested in the bottom oval of Figure 4.1. In this sense, the artistic process and the appreciation process can be seen as parallel, because the individual's direct experience is an inner one, intensely personal and private, and the interpretative experience is the attempt to express to others what that direct experience was like.

When we encounter a work of art, it moves us by communicating something akin to what the artist envisioned by drawing upon our own powers of discovery and eliciting our emotions. Unlike most human communication, which takes place through formalized discourse, art communicates through direct experience; the heart

[6] Nina Holton, a modern sculptor, writes about the struggle to embody an idea in a work of art in this way: "Tell anybody you are a sculptor and they'll say, 'Oh, how exciting, how wonderful.' And I tend to say, 'What's so wonderful?' I mean it's like being a mason, or being a carpenter, half the time. . . . That germ of an idea does not make a sculpture which stands up. It just sits there. So the next stage, of course, is the hard work. Can you really translate it into a piece of sculpture? Or will it be a wild thing which only seemed exciting while you were sitting in the studio alone? Will it look like something? Can you actually do it physically?" (Quoted in Csikszentmihalyi, 1997, p. 62).

of our response is a kind of sensing (similar to the sense of wonder we may feel when we come across great natural beauty). This immediate encounter becomes enriched by reflection upon it: the aesthetic experience is not limited to passive spectator-ship—it typically stimulates curiosity, questioning, and the search for explanation.

The common second step in the appreciation process is shared interpretation. People who are moved by a work of art often talk to others about the experience or read accounts of other people's experiences to test their own perceptions and fill out their understanding. When an individual engages in such discourse about a work of art, whether with a small circle of friends or with a broader public, he or she brings personal and subjective responses into the public sphere, joining a community that wants to enrich individual appreciation, to re-experience and promote that particular work of art, and to seek and endorse works that provide similar experiences. This ac-tivity affects both the private and the public sphere. Shared discourse influences the individual's experience of a particular work of art and can enrich subsequent experi-ences of it as well as experiences of similar works. Such discourse also reinforces a community of shared values. One way of defining "great" art is by its continued ef-fect on the public sphere throughout time. Some works, such as the plays of Shake-speare or the novels of Tolstoy, are so pervasive, speaking to many individuals over many generations, that they help shape their culture at least as much as their culture shaped them.[7]

The loop back to the artist from the appreciation process goes through the criti-cal response to art, as shown in Figure 4.1. This loop is meant to capture the influ-ence of the public's reactions to works of art—including the reactions of professional critics and other arts professionals involved in the arts discourse—on contemporary artists and the creation of new art. This influence on artistic creation takes multiple forms, from imitation of what is successful to innovation that departs from, and even pointedly rejects, prevailing models. But the artist is always embedded in a specific time and place and within a community of practice and discourse that sustains the creation of specific art, such as poetry or jazz or theater or film. "A vibrant culture," Kardish writes about film, "changes, adapts, and evolves continuously. Films alone do not make a culture resonant, but thinking, writing, and arguing about them, their makers, and their context do" (Ciment and Kardish, 2003, p. 6).[8]

[7] Although we are referring to the arts in general in this report, we recognize that not all art provides engaging aesthetic experiences that can speak to generations of appreciators. Some contemporary art, for example, does not attempt to communicate aesthetically and to provide compelling experiences. And some notions of art minimize the whole idea of aesthetic quality. The Nazi regime in Germany, for example, as well as the Marxist regime in the Soviet Union, discouraged people from judging art on the basis of its aesthetic merits and set up political and cultural criteria for determining the quality of art.

[8] This overview of the cycle of art has its roots in the humanist tradition, which has been somewhat out of fash-ion in the literary and art criticism of the last 35 years. Contemporary critics are rarely interested in the aesthetic experience that lies at the heart of every encounter with a work of art, tending to focus instead on the political

What the Artist Conveys

The history of aesthetics is in part a long argument about what art expresses, an argument that oscillates between two poles. The classical (and neoclassical) view, which was dominant for centuries, held that art was a representation—or imitation—of reality. The subsequent, Romantic view held that art was an expression of emotion and imaginative vision rather than a reflection of the external world. It is possible to see each of these accounts as oversimplifying a complex and nuanced reality. There is no good reason to disregard the convictions of the many artists who saw what they were doing as representing the natural world rather than creating beauty or meaning, but it also seems clear that the world such artists disclosed in their works was never presented as it might be in itself—neutral, uninterpreted, and set apart from human feelings and conceptual schemes. While we may find it difficult to accept some of the larger claims of the Romantics, they did teach us to see that art is invariably personal, mediated, and invested with value and emotion.

Langer (1957) describes the work of art as an "*objectification* of subjective life," "an outward showing of inward nature" (p. 9). In the act of creative expression, the artist finds images and forms (plastic, musical, kinetic, literary) that embody his or her vision in a way that can be conveyed to others. Van Gogh, for example, wrote to his brother Theo about trying to achieve "something utterly heart-broken" in his painting. He senses that his personal experience is potentially communicable to others, and his painting is an incorporation of the expressive qualities of the scene.[9]

Given this perspective, the work of art can be described as "an expressive form created for our perception through sense or imagination, and what it expresses is human feeling" (Langer, 1957, p. 255). It captures individual uniqueness—the subjective world of experience that ordinary discourse cannot communicate with sufficient power, subtlety, and depth. It expresses pain and comfort, excitement and repose, and life lived and felt. Artistic expression, therefore, fills gaps left by communication based on the natural science model of knowledge that dominates our culture. Rather than describing the world in impersonal, abstract, or mathematical terms, it presents a created reality based on a personal perspective (often surprising

and cultural assumptions the work reflects. There are, of course, critics who stand outside this tradition, such as Geoffrey Hartman and Wayne Booth. For critical discussions of this trend in academic writing on the arts, particularly literature, and its effects on aesthetic education, see "Aestheticide," in Hartman's *Scars of the Spirit: The Struggle Against Inauthenticity* (2002, pp. 211–229); Booth's *The Company We Keep: The Ethics of Fiction (1988)*, particularly Ch. IV, "The Threat of Subjectivism and the Ethics of Craft"; and Martha Nussbaum's *Love's Knowledge: Essays on Philosophy and Literature* (1990).

[9] Suzanne Langer offers an extensive discussion of the nature of expressive qualities that cannot be detached from the work of art itself in her *Problems of Art* (1957), particularly "Expressiveness," pp. 13–26.

and original) that includes the whole uncensored human being with all its feelings, imaginings, and yearnings.[10]

Aesthetic Experience and Its Intrinsic Benefits

We have suggested that art is a unique form of communication that takes as its subject the whole of human experience and that often engages an individual at the emotional and intellectual as well as the aesthetic level. One of the implications of this view of art as a communicative experience is that one must experience a work of art to appreciate its value. John Dewey's main contention in *Art as Experience* is that art is "a quality of experience" rather than a product (Dewey, [1934] 1980).

It is the experience of art that creates intrinsic benefits. In the following discussion, we identify three classes of benefits, as illustrated in Figure 4.2: private benefits that enhance an individual's life in the moment of experience; private benefits to the individual that become integrated into other activities, thereby providing public benefit as well; and effects that can be described as promoting broad public benefit. The benefits we highlight are not exhaustive, nor are they provided by all aesthetic experiences; but they are present in many kinds of encounters with art. They are also interrelated and often overlapping.

Immediate Intrinsic Benefits Inherent in the Arts Experience

We start by describing the benefits that enhance the life of the individual but do not have spillover as public effects—that is, they do not affect the public welfare in any

Figure 4.2
Many Intrinsic Benefits Are of Both Private and Public Value

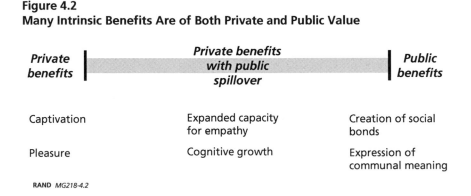

RAND *MG218-4.2*

[10] For a discussion of the difference between the scientific and aesthetic ways of perceiving and interpreting the world, see Henri Bergson's "The Individual and the Type" (1961) and Hugo Munsterberg's "Connection in Science and Isolation in Art" (1961).

demonstrable way. Because American society values individual quality of life and the pursuit of happiness, some would argue that these should be identified as being of public value. We propose, however, that these qualities are more properly viewed as private benefits that need to be present before the next order of effects can appear.

Captivation. The initial response to a compelling work of art is often an uncommon feeling of rapt absorption, or captivation—of deep involvement, admiration, and even wonder. Upon encountering the work, one is struck by something unprecedented and extraordinary in it, and one is often amazed by the feat of the creating artist—and, as in music and drama, the performing artist as well—who unleashes the expressive power of that specific medium. In this state, we are able to appreciate the particularity of things before us with unusual engagement and intensity. In other words, we appreciate specifics in a way that is rare in everyday life, where we tend to grasp things almost exclusively in terms of their relation to practical needs and purposes.

Dewey elaborates on this state by writing of the "complete interpenetration of self and the world of objects and events" that can occur in the aesthetic experience ([1934] 1960, p. 19). When we are fully immersed in the experience, its components so interpenetrate one another that we lose all sense of separation between self, object, and event.[11] This moment of seeing involves a stance of complete receptivity that James Cuno, President and Director of The Art Institute of Chicago, describes as a loss of self in a moment of absorption.[12] Philip Fisher prefers to use the word *wonder* in describing this state of complete receptivity. For him, this wonder not only stimulates close and sustained attention to what is before us, but also incites inquiry into its features so that we can come to terms with its value and meaning (Fisher, 1998, p. 39).

In its own way, each art form is capable of calling us out of ourselves and stimulating rapt involvement. What Stanley Cavell writes about experiencing *King Lear* is applicable to all compelling works of drama, fiction, or film: "The perception or attitude demanded in following this drama is one which demands a continuous attention to what is happening at each here and now, as if everything of significance

[11] Dewey takes issue with those who view the aesthetic experience as happening entirely in the mind, "shut up within one's own private feelings and sensations," a subjective experience that has no connection to the world of everyday life. Instead, he argues that the aesthetic experience resembles all significant experiences by its heightened vitality, its "active and alert commerce with the world" ([1934] 1960, p. 9). Arnold Weinstein also emphasizes that the perceiver or reader is not a disembodied mind but a fully sentient being whose responses to art are of the body (or "somatic") as well as the mind (see Introduction, pp. xix–xxxvii, in Weinstein, 2003).

[12] "We in museums offer our visitors the opportunity . . . to stop before works of art such as a Northern Song conical bowl of the eleventh century or exceptionally beautiful glazed Qingbai porcelain bowls of the twelfth century, and be absolutely arrested by them, to experience them as being outside ourselves, as they really are *in themselves*—an experience that holds promise of decentering us at a radical moment of unselfing" (Cuno, 2004, p. 51).

is happening at this moment, while each thing that happens turns a leaf of time. I think of it as an experience of *continuous presentness*" (Cavell, [1969] 2002, p. 322).

Another aspect of this form of captivation is that it often leads to imaginative flight, a departure from one's everyday self that enables one to imaginatively inhabit the created reality being presented. Weinstein (2003) writes that art is an exhilarating emancipation, "a magic venture out of our own precincts and into something rich and strange" (p. 394). Some have described this sensation as an escape from our ordinary lives into a fantasy world, and certainly many creative works provide little but entertaining fantasy. Yet apart from the compelling nature of the flight itself, this imaginative departure can foster a deep involvement with the concerns and insights of others. We will consider this aspect of the aesthetic experience when we discuss how art helps expand individual capacities.

Pleasure. One could argue that pleasure is the primary intrinsic value of arts experiences, both creative and aesthetic, and that it should be mentioned first. We place it here because aesthetic pleasure derives mainly from the captivation and imaginative flight we have just described. Csikszentmihalyi, whose study of creativity (1997) is based on interviews with 91 exceptionally creative people from the arts, sciences, business, and government, argues that we have underrated the role of pleasure in creative activity of all kinds. His subjects all talk about the joy and excitement of the act of creation itself. But that enjoyment comes with the achievement of excellence in a certain activity rather than from the direct pursuit of pleasure.[13] This emotional stimulation of creativity at its most intense is well described by the poet Mark Strand (as quoted in Csikszentmihalyi, 1997, p. 121):

> Well, you're right in the work, you lose your sense of time, you're completely enraptured, you're completely caught up in what you're doing, and you're sort of swayed by the possibilities you see in this work. If that becomes too powerful, then you get up, because the excitement is too great. You can't continue to work or continue to see the end of the work because you're jumping ahead of yourself all the time. The idea is to be so . . . so saturated with it that there's no future or past, it's just an extended present in which you're . . . making meaning.

Strand's account mirrors the cognitive and emotional benefits we described as inherent in powerful aesthetic experiences. The joy of communicating through creative work mirrors the joy of experiencing what the artist is communicating. As Fisher (1998) claims in describing wonder, both creators and appreciators of art feel delight in the experience of the new.

[13] When people are working creatively in the areas of their expertise, whether arts or nuclear physics, their various everyday frustrations and anxieties are replaced by a sense of bliss. That joy comes from what they describe as "designing or discovering something new" (Csikszentmihalyi, 1997, p. 108). See also the discussion of enjoyment's place in human life in Alisdair MacIntyre's *After Virtue*, 1984, pp. 158–160.

However, it is misleading to say that pleasure, at least in the normal sense of the word, is a necessary element in the appreciation of art. As Levinson points out: "Much art is disturbing, dizzying, despairing, disorienting—and is in fact valuable in virtue of that. We are glad, all told, that we have had the experience of such art, but not . . . because such experience is, in any natural sense, pleasurable" (1996, p. 12). There is indeed a kind of pleasure in appreciating a work of art that relates powerfully to our own experiences. As Robert Coles writes about teaching literature to medical students, "Their minds ache to give sharp, pointed expression to what they have seen and heard and felt" (1989, p. 101). But fulfilling this need is different from the kind of pleasure we feel when encountering most forms of entertainment. Levinson adds: "Better to anchor the value of works of art at least as firmly to other, perhaps more distinctive fruits of interaction with them—cognitive, emotional, imaginative—as to their capacity to afford pleasure per se" (1996, p. 22).[14]

Expansion of Individual Capacities

The "distinctive fruits" of interactions with art are the development of the individual's capacity to perceive, feel, and interpret the world of everyday experience. The benefits we just described—captivation and pleasure—are the immediate and direct effects of aesthetic experiences. The next set of benefits describes the effects of recurrent experiences on the sensibility and understanding of the individual. These effects are private benefits that spill over into the public realm by developing citizens who are more empathetic and more discriminating in their perceptions and judgments about the world around them.

Expanded Capacity for Empathy. As we have seen, one of the benefits of the aesthetic experience is that we are carried away from the familiar and drawn toward the unknown. Aristotle claimed that we need art because we have not lived enough. Art allows us to acquire experiences that our own lives could never provide. Contemporary philosopher Margaret Nussbaum makes the same point when she writes that art provides "an extension of life not only horizontally, bringing the reader into contact with events of locations or persons or problems he or she has not otherwise met, but also, so to speak, vertically, giving the reader experience that is deeper, sharper, and more precise than much of what takes place in life" (1990, p. 48).

In talking about the literary arts, Weinstein writes about this dual function in this way: "There is a startling economy at work here, a two-way street, inasmuch as the books we read flow inward into us, add to our stock, enrich our perceptions, stir our inmost feelings; yet art and literature also, quite wonderfully, draw us out, hook us up (imaginatively, emotionally, neurally) into other circuits, other lives, other

[14] Aesthetic pleasure is also distinct from entertainment. For an interesting discussion of this difference, see Glenn D. Lowry's "A Deontological Approach to Art Museums and the Public Trust" (2004).

times" (2003, p. xxvii). These experiences give us new references that enable us to become more receptive to unfamiliar people, attitudes, and cultures.

This receptivity can be unsettling and provocative, and can lead us to question our routine and conventional perceptions of the world, forcing us to look with fresh eyes on private and public questions involving sexuality, love, marriage, family, spirituality, slavery, segregation, gender, ethnicity, colonialism, and war, just to name a few of the more obvious. As Lionel Trilling (1953, p. 215) wrote about the novel of the last 200 years:

> [The novel's] greatness and its practical usefulness lay in its unremitting work of involving the reader himself in the moral life, inviting him to put his own motives under examination, suggesting that reality is not as his conventional education has led him to see it. It taught us, as no other genre ever did, the extent of human variety and the value of this variety.

Trilling and many others believe the sympathetic imagination can forge a vital link between people. "The common coin," writes Jerome Bruner, "may be provided by the forms of narrative that the culture offers us" (1986, p. 69). Nussbaum puts it this way: "Habits of wonder promoted by storytelling define the other person as spacious and deep, with qualitative differences from oneself and hidden places worthy of respect" (1997, p. 90). It is this respect for the inner life of every individual that Trilling describes when he calls the imagination of the novel-reader a "liberal imagination."

Democracies need citizens who can think for themselves rather than deferring to authority, and they need citizens with "an ability to see themselves not simply as citizens of some local region or group but also, and above all, as human beings bound to all other human beings by the ties of recognition and concern" (Nussbaum, 1997, p. 10). Experiences of the arts, according to many of these commentators, help build those ties.

Cognitive Growth. The benefits we have already described all have cognitive dimensions. As we pointed out earlier, works of art draw us out of ourselves and focus our attention on the object or performance itself, inviting us to make sense of what is before us. They regularly challenge us and contribute to our intellectual growth by requiring us to be receptive to new experiences and to relate them to our own knowledge of the world. Fisher's discussion of wonder, for example, sees a direct connection between wonder and learning: "To notice a phenomenon, to pause in thought before it, and to link it by explanation into the fabric of the ordinary." This is the essence of wonder and the origin of philosophy, science, and art (1998, p. 55).

Many commentators emphasize the appreciator's active involvement in the creation of a work of art's meaning. Social psychologist Jerome Bruner claims that a literary narrative or film is "a text whose intention is to initiate and guide a search for

meanings among a spectrum of possible meanings" (1986, p. 25). Contemporary philosopher of aesthetics Alan Goldman (1995, p. 8) writes:

> The challenge of great works to our perceptual, cognitive, and affective capacities, and their full occupation and fulfillment in meeting that challenge, removes us entirely from the real world of our practical affairs. It is in the ultimately satisfying exercise of these different mental capacities operating together to appreciate the rich relational properties of artworks that . . . the primary value of great works is to be found.

Critics writing about aesthetic experience in narrative literature, drama, and film often emphasize the active participation of the reader's cognitive and emotional faculties in discovering and interpreting the narrative, as well as the close relationship between this kind of participation and the way we learn from *all* experience.[15]

All these aspects of the arts experience provide innumerable cognitive benefits different from the instrumental benefits that increase learning aptitude in the young. This is Eisner's point when he criticizes studies of the instrumental cognitive benefits of the arts by maintaining that they ignore the unique insights that arts experiences offer. Eisner (2000) argues that the arts provide a distinctive perspective on learning that cannot be gained in other ways. He considers the benefits of an arts perspective to include the recognition that (1) qualitative relationships are important; (2) problems can have more than one solution; (3) there are many different ways to see and interpret the world; (4) learning requires the ability to adapt possibilities as they unfold rather than approaching problems with a specific purpose; (5) neither words nor numbers can exhaust what we know; (6) small differences can have large effects; (7) metaphor is important in describing experience.

Eisner and these other writers do not assume, however, that encountering one work of art, or a small number of them, is sufficient for cognitive growth. Explicitly or implicitly, all of these writers connect such growth with repeated involvement.

[15] For Ernst Cassirer, the value of art lies precisely in such dynamic interaction: "Aesthetic experience begins with a sudden change in my frame of mind. I begin to look at the landscape not with the eye of a mere spectator but with an artist's eye" (from his "The Educational Value of Art," 1943, as given in Verene, 1979, pp. 214–215). Art cannot be received in a passive way; Cassirer writes that "we have to construct, to build up these forms, in order to be aware of them, to see and feel them." It is this dynamic character of aesthetic experience that "gives to art its special place in human culture and makes it an essential and indispensable element in the system of liberal education" (pp. 214–215). A growing body of work in philosophy and literary criticism is addressing the nature of the individual's complex responses to a work of art. See Bruner, 1986; Nussbaum, 1990; and Fleischacker, 1999. Nussbaum claims that great literature is better suited than philosophy itself to conveying "the value and beauty of choosing humanly well" (1990, p. 142). Because literature actively involves us in the inner lives of characters that must make judgments in the face of complex circumstances and daunting uncertainties, we come to appreciate the difference between judging poorly and judging well. Like Nussbaum, Fleischacker describes aesthetic judgment as a complex skill that bridges the emotions and the understanding and is grounded in perception of the particulars of a situation. He argues that it is closely connected to both moral judgment and the practical reasoning that individuals use in interpreting their life experiences. He claims that these faculties, taken together, are the means by which individuals most fully express their freedom and individuality.

With experience, we become increasingly more capable of noticing and appreciating the details that make up an aesthetic whole and seeing how these details compare with those in other works and/or performances. In the best case, this capacity for noting details and considering the relationships among them invigorates our powers of observation in everyday life.

Contributions to the Public Sphere

Besides providing these personal benefits, some of which, as we have noted, also have public value, works of art provide two critical public benefits: they create bonds among people and they sometimes provide a voice for entire communities.

Creation of Social Bonds. We have already suggested that the arts establish social bonds. Some of these are instrumental benefits that can be created by many forms of organized activities other than art activities, as described in Chapter Three. Some, however, arise from shared responses to a work of art. Recurrent gatherings of a book group, for example, provide an opportunity for socializing, which builds trust, even friendship, and may create social capital. Typically, such events also provide an opportunity to share interpretations of a literary work. This kind of interaction immerses individuals in the communicative cycle of art, which creates intrinsic benefits. It can lead them to a fuller experience of the work of art and create a public space in which meanings are shared and perspectives expressed and clarified. When an entire city or state is encouraged to read the same book, as when everyone in Georgia was encouraged to read *Ecology of a Cracker Childhood*, by Janisse Ray, or millions of viewers of the television program *Oprah* read the books Oprah Winfrey recommends, the shared experience of art provides common ground for social interaction. Are such benefits personal or public? We think they are both, but because we are emphasizing the creation of special ties among people through the agency of art, we place this effect at the public end of the scale.

The communicative power of art creates these ties among people in various ways. The arts, for example, provide the means for communally expressing personal emotion. Music, dance, poetry, and visual arts have been used throughout the ages to mark significant events (birth, marriage, death, etc.), to express religious sentiments, and to capture both religious and secular narratives valued by the community. The arts are "containers for, molders of feeling" (Dissanayake, 1992, p. 46) that allow private feelings to be jointly expressed and reinforce the sense that we are not alone.

Expression of Communal Meanings. In addition to being able to "draw us out, hook us up (imaginatively, emotionally, neurally) into other circuits, other lives, other times" (Weinstein, 2003, p. xxvii), works of art sometimes manage to convey what whole communities of people long to express. To attend tragic drama in ancient Greece, for example, was to participate in the central values, myths, and ideals of Greek society, to engage in "a communal process of inquiry, reflection, and feeling with respect to important civic and personal ends" (Nussbaum, 1990, p. 15). In

nineteenth century America, to take a more recent example, writers such as Hawthorne, Poe, Emerson, Whitman, and Twain helped define the American experience—including its finest aspirations and greatest limitations—both for Americans and for the rest of the world, just as Dickens and Hardy did for Victorian England.

The arts also commemorate national trauma, national heroes, and national triumphs (consider, for example, the many memorials in Washington, DC, that are visited by millions of Americans every year), thereby recording and capturing extraordinary moments in the life of a nation. Museums, filled with such commemorative art, provide an artistic legacy that captures the history and values of entire civilizations.[16]

Art also introduces new voices into the community, voices that can redefine the fabric of the culture. Jazz is a modern example of a form of music that emerged as a powerful voice of a marginalized community and evolved into a quintessentially American style of musical expression. Through this music, the African-American experience received attention and validation, and jazz is now recognized around the world as an expression not just of an American subculture, but of American culture as a whole. In this way, art can redefine the culture and influence artistic traditions. The rise of contemporary fiction by and about women is another example of new voices helping to redefine cultures. On a smaller scale, arts festivals and national conferences can give voice to particular communities. The annual Cowboy Poetry festival not only provides a forum for the art of widely dispersed and often isolated individuals; it also has given a powerful, new identity to the small town of Elko, Nevada.

Some individual works of art were created with the explicit purpose of changing attitudes and bringing about social change: *Uncle Tom's Cabin*, *The Grapes of Wrath*, and *The Invisible Man* all provided a critical portrayal of America and galvanized the American public into recognizing the contrast between the kind of society that had been created and the kind of society that could be envisioned. Other works of art have captured the experience of a whole generation, such as Hemingway's *The Sun Also Rises*, Heller's *Catch-22*, Kerouac's *On the Road*, and the songs of Bob Dylan. Some paintings, such as Hopper's "Nighthawks," have become classics in the nation's consciousness because they express a familiar experience in American life.

[16] Glenn D. Lowry (2004), Director of the Museum of Modern Art in New York, describes museums as "a critical public forum where works of art become engaged in a complex dialogue with the public" (p. 143). Lowry also writes: "Art museums are about a discrete activity that involves the communication of ideas and values through looking at and thinking about art. They are fundamental, in this sense, to the preservation of the artistic legacy of the past and the making of that legacy meaningful to the present" (p. 141).

Conclusion

The intrinsic benefits we have set out here, taken together, form the unique contributions of the arts to individual lives and collective experience. Far from being isolated from ordinary experience, the arts, through their communicative power, enhance individual engagement with the world in ways that have both personal and public benefits. We even suggest that these effects are instrumental in that they can open people to life and create the fabric of shared values and meanings that improves the public sphere.

 In the next chapter, we examine how individuals develop the capacity and the desire for such experiences.

The Process of Arts Participation: How It Relates to Benefits

We previously indicated that a wide range of benefits can be created through involvement in the arts, but that many of them, particularly those most often cited by arts advocates, can only be created through a process of sustained involvement in the arts. One of our objectives was to identify the dynamics behind sustained involvement.

In pursuing this objective, we examined three issues: How do people initially become involved with the arts? How does the nature of the experience change with greater involvement (changes in taste, greater competence, more engagement)? Why might levels of involvement change over time? Building upon insights from the participation literature and a model developed in previous RAND research (McCarthy and Jinnett, 2001), we developed an expanded model of participation that highlights the different factors motivating occasional and frequent arts participants to attend an arts event and the reason why patterns of participation may change over time. What we found led us to suggest that the effects of arts participation are likely to accrue to an individual rather slowly at first and then build rather sharply once he or she gains familiarity with the artistic discipline and greater capacity for mental, emotional, and social engagement through the experience.

Gateway Experiences

It bears repeating that individuals are attracted to the arts not in the hope that the experience will make them smarter or more self-disciplined, but because of the pleasure, emotional stimulation, and meaning the arts can provide. These intrinsic motivations, however, are unlikely to operate before an individual has some initial experiences with the arts. Instead, they are likely to be a byproduct of the individual's initial, or gateway, experiences with the arts.

Most adults who become involved in the arts were initially exposed to them as children.[1] If these initial exposures occur early in an individual's life, they are likely the result of decisions by parents and relatives or activities at school. If these initial experiences occur later, in early or late adolescence, for instance, they are very likely to occur because of a social occasion, (e.g., an outing with friends or as part of a community function). Of central importance to an individual's inclination to continue future involvement is his or her reaction to the initial arts experience. Those who find their initial experience positive are very likely to be willing to continue their involvement.

The form that initial involvement takes can also be important to future behavior and attitudes toward the arts more generally. Many young people's first hands-on involvement with the arts is when they learn to draw, to play an instrument, to sing in a choir, or, perhaps, to act in a play. Most young people do not continue to perform as they get older, usually because the technical skills required to move beyond the intermediate level in any medium are extremely difficult and time-consuming to acquire. But if their early creative experience has brought pleasure and recognition, it can become an ideal gateway to future arts experiences because the individuals have had a positive experience with the arts, have learned the underlying techniques of an art form, and have begun to develop the ability to discriminate between a good performance and a mediocre one.[2] For others, their first experience with the arts occurs when they are taken to a performance or museum by a mentor—either a parent, relative, friend, or teacher. The best mentors are those who are deeply engaged in some form of art and want to share their enthusiasm. Such mentors can provide access to whole new domains of experience. Parents who possess what sociologist Pierre Bourdieu (1984) calls "cultural capital" provide their children with a great advantage: an environment of books, stimulating conversation, expectations for higher education, and introduction to the arts.

For those who do not have the opportunities to be introduced to the arts in either of these two ways, their first experience is likely to be popular music and film, often with friends as part of a social occasion. Whether this initial encounter leads to further arts experiences may well depend not only on whether the initial encounter is positive, but also on whether it is viewed as meaningful in itself rather than simply an opportunity to participate in activities viewed as appropriate by the person's social group.

[1] Orend and Keegan (1996) indicate that early exposure to the arts and arts education as a child are important factors in explaining the frequency of arts participation among adults. The single most important source of empirical information on participation patterns is the NEA-sponsored Survey of Public Participation in the Arts (SPPA), a national survey conducted first in 1982 and then in 1985, 1992, 1997, and 2002. The questionnaire and survey procedures have changed over time, but the SPPA nevertheless provides an invaluable source for describing arts participation in the United States and how it has changed over time.

[2] For an interesting description of research on the artistic development of children, see Gardner, 1989.

The key aspect of these initial experiences for future arts involvement is that the arts experience itself, rather than simply the social circumstances in which it occurs, engages the participant enough that he or she develops a positive attitude toward the arts and the possibility of future arts involvement. Whether this occurs may well depend on whether the initial experience is appropriate to the individual's age, interests, and life experience.

It is, of course, possible for individuals who have had little exposure to the arts during childhood to become engaged in the arts later in life. This may happen because of a chance encounter with an art form or the influence of a friend. But such gateways may not open easily for older adults who have developed no inclination toward the arts as a result of early influences. Indeed, a chief advantage of early exposure to the arts is that it can create more openness to later arts participation. For adults already attracted to some form of the arts, the appeal of social activities may lead to new arts interests: a friend or colleague with a love for a particular art form can facilitate entry into that domain. Once again, the key element of these gateway experiences is that they are positive and condition the individual to consider future arts participation.

Transforming Occasional into Frequent Participants

Continued arts participation can take many different forms, depending on the opportunities available, practical factors (such as cost, availability, competing demands on their time), and the social networks that shape the individual's decision about how to allocate time. At some point, however, the individual begins to view the arts not simply as a pleasurable way to occasionally spend time, but as an important component of his or her identity (much the same way that individuals view hobbies or sports).

At this point, the individual begins to transform from an occasional to a frequent arts participant. This distinction between frequent and occasional participants is repeatedly identified in the arts participation literature as central to patterns of arts participation. Indeed, this literature describes the potential audience for the arts as falling into one of three categories with regard to frequency of participation: those who rarely, if ever, attend; those who attend occasionally; and those who attend frequently (McCarthy, Ondaatje, and Zakaras, 2001; McCarthy and Jinnett, 2001; Schuster, 1991; Robinson, 1993). Where to draw the boundary between occasional and frequent participants is subject to some dispute (Kopczuski, Hager, and the Urban Institute, 2003), but there is little question that frequent attendees account for a disproportionate share of total attendance.

Such studies also show that frequent and occasional participants in the arts differ in a number of important ways, such as their reasons for participating (Ford

Foundation, 1974; Schuster, 1991), their tastes in the arts (McCarthy et al., 2001), and their backgrounds and experiences (Bergonzi and Smith, 1996; Orend and Keegan, 1996).

McCarthy, Ondaatje, and Zakaras (2001) suggest that frequent attendees' tastes in art differ from those of others—a pattern that is consistent with the leisure literature's finding that individuals' tastes for most leisure activities depend on their level of knowledge and familiarity with the activity (Kelly and Freysinger, 2000). Frequent attendees are also more likely to participate in multiple art forms (Peters and Cherbo, 1996). The key to understanding these differences in taste is the growing competence individuals acquire with repeated participation. And an individual's predominant mode of participation and preferred artistic discipline will determine what form this competence takes.

Individuals whose preferred mode is appreciation (e.g., attending, listening, reading) expand their knowledge of a particular art form, including both a range of artists and artistic styles. Those whose preferred mode is doing art (performing and creating) become more skilled in executing the techniques of their preferred art form and in understanding differences in interpretation. Those whose predominant mode is stewardship will develop their management and technical skills and their ties to specific arts organizations by volunteering, donating, and organizing.

As this discussion suggests, the transformation from occasional to frequent participant occurs when the individual internalizes his or her motivation for participating in the arts. At this point, the decision is no longer whether to participate, but how and when to participate—in other words, participation becomes an ongoing process.

High Levels of Engagement: The Key to Frequent Participation

Research on arts participation has not examined the factors that draw individuals toward more regular involvement with the arts. Although studies suggest that positive initial experiences with the arts predispose an individual to consider future involvement, such early exposure is not a sufficient condition for continued involvement. Subsequent participation experiences also play an important role. Whether this engagement begins to develop depends partly on the encouragement of the individual's family, friends, and other people who are significant to the individual, such as teachers. But the most important factor is likely to be the quality of the individual's successive arts experiences.

Those individuals who are most engaged by their arts experience are the ones who are the most attuned to the intrinsic benefits, and those benefits create not only positive attitudes toward the arts, but also the motivation to return. As noted in Chapter Four, high-quality arts experiences are characterized by enjoyment, a height-

ened sense of life, and imaginative departure. Individuals who have such experiences seek more of them.[3] This connection is confirmed by marketing studies that demonstrate that the nature of the consumption experience—that is, the extent to which the experience is personally satisfying—is a key influence on a consumer's propensity to make repeated purchases (Gobe, 2001; Schmitt, 1999; Underhill, 1999). Zaltman et al. (1998) report that this process is also true of the arts.

Kelly (1987), in writing about leisure activities, claims that the quality of any activity is largely determined by the participant's level of mental and social engagement in that activity. Csikszentmihalyi (1990), as noted above, describes "optimal" or "flow" experiences as those that stimulate full mental and emotional engagement—a condition requiring that the participant's skills be evenly matched to the difficulty of the task.

The arts experience does not just engage the individual's emotions and intellect; it also is a social experience and often occurs in the company of others. Indeed, our discussion of intrinsic benefits highlights the importance of art as a communicative experience and the fact that social discourse about that communication can enhance the quality of the arts experience. Moreover, McCarthy and Jinnett (2001) discuss how the most-committed participants can become immersed in a community of aficionados who view the arts (and perhaps a specific arts institution) as an essential component of their identity. Morrison and Dalgleish (1987) also underscore the importance of social engagement with an arts-focused community in transforming casual to habitual participants. Stewardship is often a highly socially engaging form of participation—serving on a board, launching an arts fair, establishing a book group. If an individual does not find at least some arts experiences at least somewhat engaging—mentally, emotionally, or socially—he or she will get very little from the experiences and is not likely to become a frequent participant.

Our analysis offers support for the view that frequent participants are those whose experiences engage them in multiple ways—mentally, emotionally, and socially. The more intense that engagement is, the more gratifying the experience. It is such experiences that make people into life-long participants in the arts. Indeed, Stigler and Becker (1977) liken the process through which an individual's growing competence in the arts increases his or her attachment to the arts experience to addiction and suggest that this process is characteristic of frequent participants.

It is possible to describe an individual's level of mental and emotional engagement with a work of art on a scale that ranges from bored/filling time, to relaxed and entertained, to involved, to fully engaged. It is also possible to describe social engagement along a scale from solitary, to interactive, to communal. For example, one might listen to music alone (solitary), interact with others at intermission (joint), or

[3] Bianchi (2002) suggests that the more "creative," or challenging, the properties of the consumable are, the more sustained the pleasure derived from consuming it.

sing along with the rest of the audience at a choral performance (communal).[4] It should be noted that cognitive and emotional engagement need not be related to social engagement. It is entirely possible, for example, for individuals to have an aesthetic experience in solitude. In fact, some forms of arts experiences may be intensified by solitude. Other people, whose preferred modes of participation are making art or stewardship, may achieve high levels of social engagement without the highest mental and emotional engagement. Moreover, engagement and competence are related but need not always be connected. As Csikszentmihalyi (1990) notes in describing the state of flow, the key consists of not just the participant's skill (or competence) level, but also the match between the participant's skill level and the nature of the challenge.

Modeling the Decisionmaking Process

Understanding the primary differences between occasional and frequent arts participants is an important step in understanding participation patterns over time. Our understanding of these patterns, however, is limited by the theoretical literature on arts participation, which tends to focus on discrete participation decisions and, in particular, on the decision to participate or not (McCarthy and Jinnett, 2001). This approach often takes too simple a view of the participation decision process and, as O'Hare and McNee (2003) point out, tends to focus on the initial decision to participate rather than whether and why individuals choose to continue their participation. Indeed, this literature often treats the decisionmaking process as though it were simply dichotomous (whether or not to participate) rather than involving, as we believe, a series of separate decisions.

As such, the growing body of empirical work on arts participation focuses on the who, what, how, and how often of arts participation, with a consequent lack of theoretical attention to the critical issues of patterns of participation over time and paths toward ongoing involvement.[5] Most of these studies use cross-sectional data to examine the participants' characteristics (the who), the disciplines they participate in (the what), their modes of participation (the how), and the frequency of participation (the how often). They do not, however, ask why people seek arts experiences. Those studies that do address this question focus on the reasons individuals cite for deciding whether or not to participate in specific arts events (Ford Foundation, 1974; National Endowment for the Arts, 1998; Robinson, 1993), which tend to be related to

[4] Adapted from Kelly, 1987.

[5] A fuller discussion of the participation literature can be found in McCarthy, Ondaatje, and Zakaras, 2001. As this earlier document notes, the empirical literature on participation is growing. This growth appears to be a by-product of the increasing availability of data on participation patterns.

practical factors (cost, availability, scheduling, general interest in the arts) rather than to individuals' underlying motivations for involvement in the arts.

As we noted above, linking participation to the benefits of the arts requires an understanding of participation as an ongoing process. Thus, it is important to understand not only how individuals are initially exposed to the arts and how they make their initial decision to participate, but also why they come back for more, what paths their involvement may take, and why patterns of participation change over time. To integrate these various ideas, as well as the interactions among experiences, attitudes, and behaviors in the dynamics of participation, we developed a model of individual decisionmaking, as illustrated in Figure 5.1.[6]

Figure 5.1
RAND Participation Model

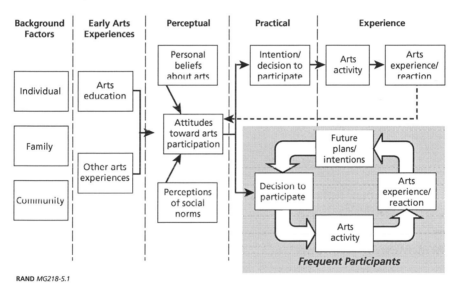

RAND MG218-5.1

[6] This model is an example of the attitudinal and behavioral models discussed in Chapters Two and Three. Readers familiar with McCarthy and Jinnett, 2001, will note that we have modified the earlier model in several ways. This expanded model, which better captures the ongoing process of participation and the important distinctions between occasional and frequent participants, has been modified as follows. (1) It now draws clearer distinctions between the various background factors to reflect our recognition of the different roles that individual, family, and community characteristics can play both in influencing an individual's attitudes toward the arts and in determining how that individual is first exposed. (2) It highlights early arts experiences, including exposure to arts education, and explicitly incorporates them between the background factors and the perceptual stage of the model. This modification recognizes the specific importance that both the benefits and the participation literature place on initial arts experiences and exposure to arts education in subsequent participation behavior. (3) It elaborates on the arts experience to distinguish the ways in which arts experiences affect frequent versus occasional participants.

The decision to get involved in the arts involves a complex mix of attitudes, intentions, constraints, and behavior, as well as feedback between past experiences and the mix of attitudes and intentions. It also recognizes that the arts participation decision is not a simple dichotomous behavior (to participate or not), instead involving a complex set of considerations. Indeed, the key to our model is the recognition that there are several separate considerations, or stages, embedded in an individual's decisionmaking process and that different factors affect each stage. *Background factors* and *early arts experiences* shape the individual's *perceptions* of arts experiences and his or her predisposition, or inclination, to participate. The *practical* stage involves the individual's evaluation of specific participation opportunities. Following that is the individual's actual participation *experience* and subsequent assessment of his or her inclination to continue to participate.

Shaping Perceptions and Inclinations: Background Factors and Early Arts Experiences

Before individuals actually consider participating in a specific arts event, they must first be inclined to participate. This inclination is determined by their beliefs about what the arts have to offer them and their perception of the operative social norms toward the arts. In other words, the decision to consider the arts is largely determined by perceptual factors, which, in turn, are influenced by background factors (individual, family, community) and early arts experiences (arts education, other arts experiences). To elaborate,

- **Individual factors** include personality traits and personal tastes and talents (including, for example, different abilities in the multiple intelligence dimensions discussed in Chapter Two). These characteristics help shape the individual's predilection toward the arts, as well as the appeal that different modes of participation and disciplines will hold for him or her.
- **Family factors** include such characteristics as sociodemographic background (including parental education), resource levels (both time and money), and exposure to the arts in the home that, in turn, help shape the individual's attitudes toward arts and culture, tastes for specific art forms, and opportunities to participate in the arts outside the home.
- **Community factors** include peers and other sociocultural influences on the individual, the cultural and artistic opportunities available in the local area, and the character of the schools (including school-based art programs) to which the individual is exposed. These factors not only help shape the individual's attitudes toward arts participation, but also influence the likelihood that he or she will be exposed to the arts and the form that the exposure might take.

As suggested by the attitudinal and behavioral literature, the importance of these different clusters may well change as the individual matures. Family influences, for example, may well be the most important factors prior to late adolescence, when community factors may become more important. For adults, individual factors may be the most salient. Once the individual is inclined to participate, he or she is then ready to consider specific participation opportunities.

Our revised model no longer groups early arts experiences as one of several background factors. Instead, it highlights early arts experiences as a separate stage of the model and, within that category, distinguishes between arts education and other early arts experiences.

We built on the insights provided by other studies in arriving at the relevant features of arts education. They include the context in which the arts education takes place (e.g., school, private lessons, community setting); the nature of the arts education (e.g., classes in art history or arts appreciation, classes in the various forms of doing or creating art); and the duration and frequency of the arts education. As we suggest in our review of the empirical and related theoretical literatures (see Chapter Two and the Appendix), the nature and quality of the arts education experience, the individual's reaction to the experience, and the benefits he or she derives from it all vary with these factors.

Similarly, the salient features of other early arts experiences include the following: (1) the context in which the experiences occur—e.g., being taken to a performance by a family member or friend,[7] or in the course of some other community activity (such as singing in a choir at church); (2) the mode of the experiences—e.g., appreciating (such as attending a live performance or visiting a museum) or doing (such as singing in a choir); and (3) the frequency of the experiences—e.g., regularly or occasionally.

From Practical Considerations to the Arts Experience

Once the individual has developed an inclination for the arts, his or her decision to take advantage of opportunities to participate will depend on a host of practical factors—scheduling, price, opportunity costs, etc. Once having participated, the individual then must decide whether to consider participating again. This decision is primarily driven by the individual's reaction to the actual experience.

However, if at some point the individual becomes a frequent participant, the decisionmaking process no longer includes *whether* to participate but, instead, *how* and *when* to participate. That is why the loop in Figure 5.1 for frequent participants stays within the practical stage in lieu of going back to perceptions. The motivation

[7] As we have already noted, many individuals' first experiences with the arts are brought about not by the individual's own initiative, but for social reasons (e.g., being brought along by a family member or friend).

to participate has now been internalized. As Stebbins (1992) notes, for some habitual participants, the arts experience becomes an end in itself.

Key Determinants of Arts Participation Decisions for Frequent Participants

Figure 5.2 is a more detailed rendering of frequent participants' decisionmaking cycle (shown as the shaded area in Figure 5.1). The cycle starts with the decision to participate (the left-hand box), a decision that, like those of other participants, is typically made in terms of specific practical factors—for example, costs, schedule, location, and alternative opportunities. However, given their predisposition toward the arts and their distinctive tastes, frequent participants may not weigh the costs and benefits of various practical factors the same way that others do. They are, for example, likely to rate the benefits of participating in a specific artistic event more highly than others do, and they may also rate the costs of participation lower. Their decision to participate entails a choice of arts activity, as shown in the next box in Figure 5.2. This includes the mode of participation, the artistic discipline, and the nature of the event or activity chosen.

The key to the participation cycle is the arts experience. As suggested earlier, the quality of that experience is best indicated by the level of the individual's mental, emotional, and social engagement in the experience. The participant's level of engagement conditions his or her future participation choices in two ways: these experiences increase his or her level of knowledge and competence (and thus affect his or

Figure 5.2
The Cycle of Participation for Frequent Arts Participants

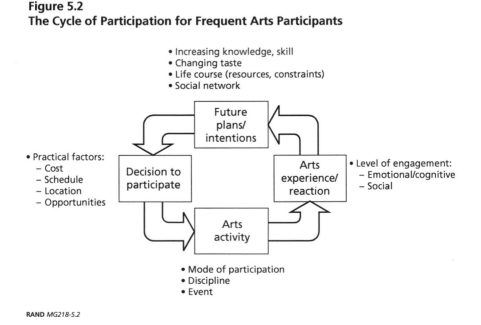

RAND MG218-5.2

her tastes) and influence his or her expectations about specific disciplines, artists, companies, etc. In combination, these experiences then affect the participant's future plans and intentions with respect to future participation. The frequent participant's experiences differ from those of the occasional or first-time participant in that they do not influence his or her attitudes about the arts (and thus the likelihood of future participation) as much as they influence his or her attitudes about specific types of participation (in terms of discipline, artist, mode of participation).

This model also allows us to capture the fact that frequent participants change the nature of their participation over time. As the frequent participant gains in experience, competence, and familiarity with the arts in their various forms, his or her tastes and expertise may change, and these will affect decisions about future participation. But past experiences are not the only factors that can lead the frequent participant to change his or her pattern of participation. Over the course of a lifetime, an individual's personal circumstances—family situation, education, earnings, time constraints, place of residence, job, and a host of other factors) also change. Moreover, as an individual becomes more established in the community and accumulates social capital, his or her ties to specific organizations (both arts and other institutions) may also change. In combination, these changes may lead the person to shift in terms of modes of participation (from doing, to appreciating, to stewardship, for example), preferred arts disciplines, and a variety of other aspects of involvement.

But the key to this participation model, for all types of participants, is the intensity of engagement—mental, emotional, and social—in the arts experience. Only those who are capable of high levels of engagement in the arts experience become frequent participants. The implication of this insight is that occasional participants must be introduced to compelling arts experiences if they are to be converted into frequent participants.

Cumulative Effects of Arts Participation

As we noted earlier, some benefits may be realized at all levels of involvement in the arts; but the results of our analysis suggest that the higher-order benefits require sustained arts involvement. Intrinsic benefits build over time as the individual becomes more perceptive and more skilled at interpreting what he or she experiences. The process of frequent arts involvement is likely to develop competencies within a given domain that increase the emotional and mental intensity of the experience. One becomes more familiar with the art form—its rules and symbols, its standards, its most gifted practitioners. As the individual develops such knowledge, he or she becomes more discerning and more selective. This pattern is consistent with the leisure literature's finding that the individual's tastes for most leisure activities depend on his or her level of knowledge and familiarity with the activity (Kelly and Freysinger, 2000).

A similar process appears to be involved in acquiring the instrumental benefits that the arts can provide. As we discussed in previous chapters, the level of involvement in the arts needed to generate different types of instrumental benefits is likely to vary depending on the nature of those benefits. However, it seems that the more important the benefit is, the greater the level of involvement needed to acquire it.

Figure 5.3 is a notional graphic illustrating how different levels of arts involvement might be related to the production of benefits. Four models (A through D) are shown, each one representing a different relationship between the levels of arts involvement and the production of benefits. Model B, which is the most prominent of the four in the figure, is the most pertinent representation for many of the benefits we have discussed.

Model A represents a situation in which the level of the benefits produced increases as a direct, or linear, function of the level of arts involvement. This model is consistent with an activity-based relationship in which the greater the level of activity (e.g., the more tickets sold), the higher the level of economic benefits to the local community.

Model B, which is the closest portrayal of what occurs for many of the benefits we have discussed, shows that the level of benefits remains rather modest at low levels of involvement in the arts; but at a certain point, as the level of involvement makes slight increases, it builds rapidly. Once an individual understands how to become engaged in an arts experience—what to notice, how to make sense of it—the rewards of the experience are both immediate and cumulative. Participation via stewardship

Figure 5.3
The Relationship Between Level of Involvement in the Arts and Level of Benefits

can follow a similar dynamic, as a function of regular attendance or organizing others. An individual or community might build social ties over time and then leap up to higher levels of individual and community benefit, crossing thresholds. Model B is also consistent with what we have said about how the arts can facilitate the process of learning how to learn. In other words, in order for the various components of the learning process to come together, the individual must reach the level of initial investment needed to build a base of knowledge about the arts (through mentoring, feedback, etc.) and to develop the personal skills needed to put this knowledge into practice. Once this learning process starts, even small incremental changes in the individual's level of involvement can bring high levels of benefits.[8]

Model C is the most consistent with the situation in which the arts are used to help individuals understand subjects other than the arts. Because the benefits in this case are produced by triggering individuals' different forms of intelligence, or learning styles—which individuals already possess—the benefits accrue fairly immediately (e.g., they show up in tests of the ability to recall specific information). However, because benefits produced this way do not typically transfer to other subjects (or even necessarily to the next pieces of information), they are likely to level off.

Model D represents the involvement-to-benefits relationship that might occur when the individual's arts experience is negative—that is, it fails to engage the participant *and* it causes that participant to disengage from the arts. In this case, any initial positive effects of arts involvement may turn negative.

In general, we suspect that the types of involvement needed to trigger benefits are likely to depend on the nature of the benefit, the participant's level of knowledge and development, and the context in which the participation takes place. As a general rule, the higher the level of benefits is, the higher the level of arts involvement must be to generate it.

Bottom Line

Since the key to being able to gain benefits from the arts lies in being brought into a process of recurrent compelling encounters with works of art, we have tried to illuminate both the factors that trigger arts involvement in the first place and the factors that help that arts involvement deepen over time. As we discuss in the next chapter, the arts community and cultural policymakers should renew their attention to these critical processes in order to bring more people into the kind of sustained involvement with the arts that can enhance their lives and enrich the public sphere.

[8] The relationships depicted in Figure 5.3 are only notional. Model A's slope might be steeper or more gradual for different types of benefits, just as the inflection points in Models B, C, and D might occur earlier or later in terms of the levels of involvement required to realize the benefits.

Conclusions and Implications

The arts in America expanded dramatically from the 1960s through the 1980s, but they have faced difficult times since then. They have had to navigate a new landscape, one in which demand for the arts has shifted in response to leisure time becoming more fragmented, the population growing more diverse, and competition from a burgeoning leisure industry intensifying. They have also had to deal with many changes—in distribution patterns stemming from emerging technologies; in an organizational ecology that is blurring the distinctions among the commercial, nonprofit, and volunteer sectors; in public and private funding patterns; and, most recently, a prevailing attitude toward government that emphasizes accountability and empirical justification for public support.

For arts organizations, these trends have increased the difficulty of identifying and attracting audiences, managing resources and budgets, competing for and justifying funding, and justifying their public role. The response of arts advocates—including many state arts agencies, legislative advocates for the arts, and arts organizations—has been to focus on the instrumental benefits of the arts, particularly economic growth and improved academic performance and pro-social behavior among the young. These arguments have borrowed extensively from the terminology of economics and the social sciences, stressing quantitative measurement of costs and benefits and empirical demonstration of effects as a rationale for support of the arts.

Problems with the Current Policy Approach

There are three major problems with the current approach. The first is that it relies too heavily on instrumental arguments. The second and third are that it ignores the intrinsic benefits of the arts and is primarily tailored to serve the financial needs of the nonprofit arts sector.

Problems with Instrumental Arguments
There are several reasons why the current reliance on instrumental arguments is not likely to be convincing:

- **Weakness in empirical methods.** Many studies of the arts' instrumental effects are based on weak methodological and analytical techniques and, as a result, have been subject to considerable criticism.
- **Absence of specificity.** The empirical literature on instrumental effects lacks critical specifics about such issues as how the claimed benefits are produced, how they relate to different types of arts experiences, and under what circumstances and for which populations their effects are most likely to occur. Without these specifics, it is difficult to judge how much confidence to place in these findings and how to generalize from the empirical results.
- **Failure to consider opportunity costs.** Instrumental arguments for the arts tend to ignore the fact that the benefits they claim can all be produced in other ways. Cognitive benefits can be generated by better education—that is, by providing more-effective reading and mathematics courses. Economic benefits can be generated by other types of social investment, such as a new sports stadium or transportation infrastructure. An argument for the arts that is based entirely on instrumental effects runs the risk of being discredited if other activities are better at generating the same effects or if policy priorities shift. Because the literature on instrumental benefits fails to consider the comparative advantages of the arts in producing instrumental effects, it is vulnerable to challenge on these grounds.

Insufficient Emphasis on Intrinsic Benefits

Many arts advocates are uncomfortable with an exclusive reliance on instrumental arguments but are also reluctant to emphasize the intrinsic aspects of the arts experience lest such arguments fail to resonate with funders. The problem with this reluctance is that it ignores two important facts: intrinsic benefits are the principal reason individuals participate in the arts, and the intrinsic effects can produce public benefits of their own.

Undue Emphasis on Arts Supply and Financial Support

The current instrumental arguments are typically cited in the context of efforts by nonprofit arts organizations to secure public financial support. These arguments are often viewed as self-interested and are weighted accordingly. They are predicated on the assumption that the principal function of public arts policy should be to maintain a supply of nonprofit arts. They also raise the issue of equity, because all taxpayers are asked to support activities of people involved in the arts, a group generally more affluent than nonparticipants. This supply-side approach to arts policy downplays the importance of building demand for the arts because the arts can enrich individual lives and enhance the public welfare.

A New Approach

We argue in this report for a new approach to building support for the arts, an approach based on a broader understanding of the benefits of arts involvement. This approach recognizes the ways that both intrinsic and instrumental benefits contribute to public welfare. It also recognizes the central role intrinsic benefits play in generating all benefits, and the importance of developing policies that ensure the benefits of the arts are realized by greater numbers of Americans.

A Broader View of the Public Benefits of the Arts

We propose a view of the benefits of the arts that is broader than the current one in that it incorporates intrinsic and instrumental benefits and distinguishes among the ways in which the arts can affect the public welfare.

Our framework recognizes three ways in which the arts can benefit individuals and communities. First, the arts can provide a variety of benefits that are primarily personal, or private, such as providing pleasure or relieving the anxiety felt before undergoing a medical procedure. Although these benefits can improve an individual's life, they do not necessarily contribute to the wider society's welfare. Second, the arts can provide to individuals both intrinsic and instrumental benefits that have a spillover effect on the society. For example, the arts can promote the development of learning skills that are of benefit to the society—a fact attested to by society's willingness to supply these effects directly (e.g., by providing public education). Third, the arts can provide a range of benefits to the public as a whole (i.e., to both those involved in the arts and those not involved in the arts), such as increasing economic growth and social capital.

The traditional view assumes that all intrinsic benefits of the arts are purely private and thus ignores their wide-reaching public value. The truth is, the arts can create and foster a range of intrinsic benefits that are primarily personal, but they can also generate private benefits that have indirect, spillover effects on the public sphere, as well as direct effects on the public sphere. As we pointed out in Chapter Four, for example, the arts experience can promote greater individual receptivity to new perspectives and tolerance for others, two private benefits that provide clear spillover benefits to a society whose population is growing increasingly diverse and whose central values include free speech and freedom of religion. Moreover, the ability of the arts to express communal meaning and present expressions of shared cultural heritage are intrinsic benefits that have broader public value.

Although one can debate the position of specific benefits along this continuum from private to public value, this basic framework helps illustrate that many instrumental and intrinsic benefits create not only personal but public benefits.

The Central Role of Intrinsic Benefits in Arts Participation

Again, individuals' decisions to become involved in the arts are principally driven by the intrinsic benefits the arts provide. Whether it is the immediate delight and wonder that the arts experience can trigger or the cognitive benefits that come from more sustained arts involvement, the intrinsic benefits derived from the experience are what motivate individuals to become involved in the arts. Indeed, only by focusing on individual experience can one understand how individuals become drawn to the arts in the first place, how they develop sustained interest, and how they access many of the effects we have described. From this perspective, it becomes clear that not much is gained by separating the discussion of instrumental effects from that of intrinsic effects—the two are intimately linked. Participation in the arts is motivated by intrinsic benefits derived from arts experiences, and it is only through such experiences that a variety of instrumental benefits can be realized.

Factors Behind Sustained Arts Involvement

We have indicated that a wide range of benefits can be created through involvement in the arts, but that many of these benefits—particularly those most often cited by arts advocates—require a process of sustained involvement. In analyzing the dynamics of sustained involvement, we highlighted three factors.

The first of these factors is the gateway experiences that acquaint individuals with the arts and present immediate benefits. Although these experiences can occur at any age, they appear to be the most effective in terms of developing positive attitudes toward the arts and an inclination to continue an involvement in the arts if they occur when a person is young. The second factor is the quality of the arts experience. Individuals pursue continued involvement in the arts if their arts experiences are fully engaging—emotionally, cognitively, socially. Continued involvement develops the competencies that change individual tastes and enrich subsequent arts experiences. The third of the three factors is the transformation of an individual from a casual, or occasional, participant to a frequent participant. The key element of this transformation is that the desire for more arts experiences becomes internalized and the key participation decision changes from whether to participate to how to participate and when.

We believe that our approach, which is based on an understanding of the dynamics of sustained involvement, offers a stronger rationale for support of the arts than a purely instrumental argument does. Our approach emphasizes the variety of benefits the arts can provide to individuals and to the public. In addition, it underscores the importance of intrinsic benefits both as the central reason why individuals become involved and as a source of personal and public benefits. And it underscores the vital role of individual arts experiences in this whole process.

Policy Implications

The key policy implication of this analysis is that greater attention should be directed to introducing more Americans to engaging arts experiences. Such an approach would require that attention and resources be shifted away from maintaining the supply of the arts and toward cultivating demand. A demand-side approach would aim to build a market for the arts by cultivating the capacity of individuals to gain benefits from arts experiences. Calls to broaden, diversify, and deepen participation in the arts, of course, are hardly novel. But too often efforts to do this have been hampered by a lack of guiding principles. Our view that arts benefits are grounded in compelling arts experiences highlights the importance of taking steps to develop the capacity to engage in such experiences. And our analysis of how individuals acquire a life-long commitment to the arts suggests a variety of ways to promote this objective.

Because this policy emphasis is founded not on the need to support a particular sector of the arts but, rather, on the need to promote private and public benefits of the arts, it is more likely to gain broad-based support. Concern about the health of various cultural sectors is of secondary interest, at best, to most consumers of the arts. Their focus is on the arts experience, not on the organizations and institutions that present it. This is not to denigrate the nonprofit arts sector, the arena in which much of America's arts are produced. Instead, it is to suggest that arguments for the arts should acknowledge the role of the commercial and community-based sectors in making the arts accessible to the public. As our review of the empirical literature highlights, most of the claimed learning and behavioral benefits are generated by arts experiences in schools, which are not part of any arts sector. Similarly, research on the arts' social effects points to community-based programs as the major locus of such benefits.

Policies that focus on building individual capacity for arts experiences should find broad support among the American people. According to public surveys, for example, over 75 percent of Americans agree that the arts "are a positive experience in a troubled world," "give you pure pleasure," and "give you an uplift from every day experiences," and that they would miss the arts if they were no longer available in their communities (Americans for the Arts, 2001). Similarly, DiMaggio and Pettit (1999) report in their review of public surveys about the arts that nearly 90 percent of the public routinely agree that the arts are vital to the good life and that they enhance the quality of communities.

Further testimony to the value Americans attach to the arts in general is suggested by how much importance they attach to the arts in their children's education. A Harris poll reports that a majority of parents think the arts are as important as reading, math, science, history, or geography (Harris, 1992). Close to 90 percent of American parents believe the arts should be taught in school, over 90 percent believe the arts are an important part of a well-rounded education, and 95 percent believe

that the arts are important in preparing children for the future (Americans for the Arts, 2001). This breadth of public support testifies to the extraordinary value our society places on the arts—a positive view so widespread that it practically calls out for policies that can tap into it for strong grassroots support.

Recommendations

We recommend a number of steps the arts community might take in order to redirect the way it promotes the benefits of the arts. These recommendations are offered as preliminary ideas and are meant to initiate the process of public deliberation that must take place before sound policy, informed by policy analysis, can be created.

- **Develop language for discussing intrinsic benefits.** The arts community will need to develop language to describe the various ways in which the arts create benefits at both the private and the public level. The greatest challenge will be to bring the policy community to explicitly recognize the importance of intrinsic benefits, which can only be done by making that community aware of the need to look beyond quantifiable results and examine qualitative issues. Intrinsic effects may not ultimately be susceptible to rigorous quantitative analysis, but their removal from the public discourse is equivalent to ignoring the defining element and essential appeal of the arts.[1]
- **Address the limitations of the research on instrumental benefits.** Since arts advocates are unlikely to (and should not) abandon benefits arguments in making the case for the arts, it is important to develop the credibility of these arguments by being more specific about *how* they make the benefits case. Both the research and the arts communities need to more closely examine instrumental benefits. As DiMaggio (2002) notes, much of the discussion of these topics, in public discourse as well as research studies, implicitly commits at least one of three fallacies: that exposure to the arts, in whatever form, can be approached as a single phenomenon; that a particular arts experience will have similar effects regardless of the context in which it occurs or the characteristics of the individual involved; and that the effects of arts exposure are linear. These types of problems cannot be avoided without further research on the issues, and the research must take advantage of the theoretical and methodological insights available in the non-arts literature. Moreover, the research must not be limited, as it now is, to instrumental benefits.
- **Promote early exposure to the arts.** Early exposure is often key to developing long-term involvement in the arts. As the close correlation between arts in-

[1] DiMaggio (1996) has demonstrated that empirical analysis can be conducted on intrinsic benefits.

volvement and level of education suggests, families with abundant cultural capital typically provide a blend of early arts exposure for their children. But for individuals lacking such family backgrounds, initial exposure to the arts is likely to occur in one of three ways: at school, in community-based arts programs, or through popular commercial entertainment.

The most promising way to develop audiences for the arts is to provide well-designed programs in the nation's schools. Currently, arts education is most likely to take place in elementary school (where the focus is almost entirely on making art), and then all but disappears in middle school and high school except in literature courses and such extra-curricular activities as school plays and bands. Two factors that contribute to this situation are insufficient funding for arts programs in schools, and insufficient cooperation between the world of education and professionals in the arts world.

However, more funding and greater cooperation between educators and arts professionals will not make much difference unless they are harnessed into effective programs. Fortunately, there is a body of research on how to build effective arts education programs, and most of it calls for approaches that focus on appreciation, discussion, and analysis of art works as well as artistic production.[2]

Community-based arts programs, if well designed and well executed, can also be an effective way to introduce youth to the arts (Heath, 1999). However, these programs usually have even fewer resources than school-based arts programs do and must overcome great obstacles to succeed.

Another means of facilitating early arts involvement is to tap into young people's involvement in the commercial arts. The experiences of adolescents and young adults with film, for example, would be a natural pathway for engaging them in discussions and expanding their ways of seeing and assessing this highly popular art form. High school courses that introduce students to the best of both American and international films could be appealing and effective avenues to fully engaging arts experiences.

- **Create circumstances for rewarding arts experiences.** As we have indicated, the key to transforming occasional into frequent participants is to increase their emotional, cognitive, and social engagement in the arts experience. Building individual competence in the arts and developing the individual's ties to arts organizations are effective ways to amplify that engagement. Community-based organizations may have distinct advantages in promoting this process, particularly for adults who have little prior experience with the arts. By their nature,

[2] Howard Gardner (1989, pp. 76–77), for example, writes that "artistic learning should be organized around meaningful projects, which are carried out over a significant period of time, and allow ample opportunity for feedback, discussion, and reflection. Such projects are likely to interest students, to motivate them, to encourage them to develop skills; and they may well exert a long-term impact on the students' competence and understanding. As much as possible, 'one-shot' learning experiences should be spurned."

these organizations tend to concentrate on arts experiences that are of particular interest to their communities. But all arts organizations can do more to provide their audiences with compelling arts experiences, including offering educational seminars that help participants develop the capacities for appreciating a more-challenging repertoire.

Taken together, these strategies would help expand the cycle of arts communication and spread the reach of arts effects. After all, the existence of works of art alone does not make for a vital arts culture: It is the interplay between artistic creation, aesthetic enjoyment, and public discourse about art that creates and maintains such a culture. The goal of public policy should be to bring as many people as possible into engagement with their culture through meaningful experiences of the arts.

Review of the Theoretical Research

We conducted a broad review of the theoretical literature in those disciplines that examine learning and behavioral change at the individual level and social and economic change at the community level, our objective being to discover relevant theories. Our search began with the works referenced in our review of the empirical literature. We then consulted with subject area experts at RAND and elsewhere, asking them to identify key authors and texts in their fields. These provided references that we followed, then finding further references in the next set, and the next, and so forth. Our review was necessarily high level and selective, and because of its nature will be open to challenge from experts in these fields. Despite this limitation, however, we thought it best to search widely for concepts that might help explain how the arts transmit various benefits.

In certain disciplines, such as those that explore cognitive development and community-level change, the theoretical literature lays out a range of concepts that we have synthesized to help explain how benefits are produced. In others, such as the literature on behavioral and attitudinal change and economics, there are clearly specified theories that offer alternative explanations for the benefits discussed in the benefits literature. We begin by discussing the relevant theories for individual effects—cognitive followed by attitudinal and behavioral[1]—then turning to community effects—social followed by economic. We introduce each section by identifying the theoretical literature consulted and the selection criteria used. In discussing how these concepts are related to the arts participation experience, we have also tried to identify whether the benefits derive from the special characteristics of the arts or whether the arts simply provide a useful context for triggering the underlying mechanism. This issue is particularly important in comparing how the arts compare with other ways to trigger these benefits.

Our review suggests that there are, indeed, a variety of theories capable of explaining how the arts can trigger a variety of instrumental benefits. It also suggests

[1] We did not attempt to explore the theoretical literature that might inform the health effects of the arts. Our reason for this, as noted, is that the empirical literature in this area is not well developed and is basically atheoretical.

that the underlying theories can help to distinguish why certain benefits are more important than others and why the arts may be a particularly useful way to trigger those benefits. Finally, it indicates that a process of sustained involvement in the arts is needed to generate the type of personal and public instrumental benefits offered by the arts.

Theoretical Insights on Cognitive Benefits

We selected works that would enable us to (1)identify the key components of the learning process and (2) discuss how the arts and arts participation can trigger cognitive benefits. This review thus focuses more on determining how the arts promote learning and learning skills than on presenting a general theory of learning and human cognition.

In the studies we reviewed, we identified six different approaches to understanding the learning process, each with its own particular focus: (1) cognitive psychology, which examines factors that condition different forms of learning (recall, application, and transfer) and how different types of intelligence condition the way people learn; (2) linguistics, which focuses on the role and use of language and syntax in influencing how individuals perceive and structure reality; (3) neurobiology, which examines the physiological basis for learning and how it relates to the development of learning skills; (4) social psychology, which examines the role that social and personality factors play in the learning process; (5) educational psychology, which looks at the importance of materials and pedagogical techniques; (6) experimental psychology, which studies how individuals organize, recall, and process information. We reviewed studies in all of these fields, but then did focus reading in those we found to be the most useful for our purposes: cognitive psychology, experimental psychology, and social psychology. Although we uncovered no single comprehensive theory of human cognition, we were able to identify a series of key concepts about learning that help explain how the arts might contribute to learning. We summarize these key concepts next.

Key Elements of the Learning Process

The Contextual Nature of Learning and the Role of Scripts. Learning occurs in a wide variety of contexts and involves a range of types of knowledge. Thus, learning how to read in a classroom, learning how to build a bench, and learning how to behave in different social settings are all examples of the learning process. At root, this process involves relating new experiences and information to existing bodies of knowledge. As Bransford puts it, "To grasp the meaning of a thing, an event, or a situation, is to see it in relationship to other things" (1979, p. 136). Simply having knowledge is not enough to learn and understand; knowledge must be placed

within a context or framework for learning to occur. Learning how to read, for example, requires knowledge of letters and concepts that can be represented by various combinations of letters. Similarly, learning mathematics requires a knowledge both of numbers and a variety of concepts for combining those numbers.

Indeed, knowledge is activated by relating new experiences and/or facts to frameworks, or bodies of knowledge, about how the world works. These frameworks are referred to as scripts, or schemata (Bransford, 1979; Novak, 1985). Bransford (1979) explains that schemata represent implicit ways of looking at how things work that people use to make sense of what they hear, read, and see and thus make sense of these events, stories, etc. As such, they are critical for the learning process; they help fill in the details by providing assumptions about what elements of a thing are important and how they fit together. Learning thus involves synthesizing what one experiences into these scripts. These scripts not only provide a framework within which to make sense of particular pieces of information or experience, they are also modified when that information or experience does not fit the model (Piaget, 1952). Indeed, the literature suggests that the nature of these models, and thus the way individuals perceive and understand phenomena, change as individuals change.

Moreover, the models or scripts that people use progress from intuitive (based on observation and entailing the development of a natural understanding of how things work), to rule based (characteristic of school-based learning and stressing the acquisition of literacies, concepts, and the disciplinary forms of school), to disciplinary (involving the mastery of skills and concepts of a particular domain). In sum, the models become progressively more sophisticated as different fields are mastered. This distinction is important, because, as we will show, integrating the teaching of concepts with practical "hands-on" problems—as is often done in the arts—appears to have decided pedagogical advantages over the typical school-based approach of separating the teaching of concepts from practice (Levine, 2002).

Learning Involves Both Assimilation and Accommodation. As noted above, scripts are used to put experiences, facts, and observations into contexts, but they are also modified as experiences fail to fit into these contexts. Piaget (1952) describes the development of new skills as involving a process of assimilation and accommodation. In general, *assimilation* refers to the uses of pre-existing knowledge, or schemata, to interpret information; *accommodation* refers to the modification of schemata in light of new information. In other words, scripts, or schemata, not only are used to clarify new information; they can also be clarified by that information.

Different Forms of Intelligence and Kinds of Learners. Individuals have many different forms of intelligence that they can use in the learning process. These capacities are much broader than the linguistic and logical/mathematical modes of learning that are emphasized in scholastic approaches. Gardner (1999), for example, identifies eight different types of intelligence: language, logical-mathematical, spatial, musical,

naturalist, kinesthetic (using the body to solve problems or make things), interpersonal (understanding other individuals), and intrapersonal (understanding ourselves).

Not only can individuals learn in each of these different ways, but the strengths of these different forms of intelligence vary from individual to individual. Thus, the ways in which these forms of intelligence are involved and combined to carry out different tasks and to solve diverse problems also differ. As an example of the importance of these different faculties to the learning process, Bransford cites studies showing that when poor readers were taught to create image "pictures" of the words they were hearing, they were better able to recall and understand what they had heard. In other words, activities such as visualizing and verbalizing have implications as distinct modes of acquiring new information, and different people have different preferences and abilities for different learning modes.

Learning How to Learn and the Role of Feedback. The degree to which individuals understand the concepts they learn can be measured in terms of their ability to apply those concepts in different circumstances. The first step in learning appears to be the ability to recall new information. The next step is being able to apply that information to different contexts: first, to contexts similar to the one in which they first acquired the information, and later to new contexts. The ability to use learned information in a new context is called *transfer* and is the most advanced form of learning.

To become effective learners, individuals must monitor their own learning process. To do this, they have to develop specific criteria to guide a self-evaluation of their own learning process—in other words, they must develop the ability to know when they understand what they have learned. There are several elements to this. For example, individuals need to understand which of their forms of intelligence, or faculties, must be exercised to absorb, or process, the information presented to them. In addition, they need to realize that "feedback"—which in this context means expressing what has been learned in various forms—is central to the process. Indeed, "Perhaps the most important factor underlying our ability to learn is the availability of criteria for evaluating the adequacy of our present level of understanding. Without feedback indicating that things are not quite right, we will fail to perform additional activities that might correct our understanding" (Bransford, 1979, p. 194).

An important component of feedback is the criteria used to evaluate an individual's level of comprehension. These different criteria correspond to the different levels of understanding discussed above: recall, applying information to the same context; and transfer, applying that information in different contexts. As this description implies, learning how to learn involves changing the criteria used to evaluate the degree of understanding. As Bransford puts it, applying information in the same context in which it was learned may result in a minimum of initial confusion (as compared to applying it in a different context), but may also signify that individuals are less adept at transfer.

Thus, the ability to adjust the context or criteria used to monitor one's comprehension as part of the feedback process is very important in determining whether one will increase one's understanding, stay at the same level of comprehension, or become confused depending on the context. Moreover, as individuals develop knowledge of more areas in which they can apply their knowledge, they appear to increase their ability to monitor their learning.

Self-Efficacy and the Learning Process. As this description of the learning process implies, learning how to learn requires not just intellectual skills, but the development of personal and psychological skills as well. Specifically, the process of learning involves the development of self-regulation and planning. A critical concept, which we will return to in the discussion of attitude formation and behavioral change, is the notion of perceived self-efficacy. Self-efficacy, according to Bandura (1977), is concerned with judgments of how well one can execute courses of action required to deal with perspective situations. Zimmerman (1995) stresses that self-efficacy improves individuals' abilities to learn in four ways: (1) it increases their confidence in their ability to solve problems, (2) it induces them to expect success and to attribute that success to themselves, (3) it helps them cope with the stresses and frustrations inherent in the learning process, and (4) it leads them to engage in situations in which they are likely to succeed and to avoid situations in which they might fail.[2]

Because self-efficacy fosters engagement in those learning activities that promote learning competencies, it affects achievement as well as motivation. Moreover, while efficacy beliefs are influenced by success in learning and promote the acquisition of learning skills, they are not merely a reflection of them since students with the same level of cognitive skill development vary in their performance depending upon their level of perceived self-efficacy.

Theoretical Insights on Attitudinal and Behavioral Benefits

Theories of attitude formation and behavioral change can be found in a number of disciplines, including social psychology, clinical psychology, behavioral psychology, and sociology. Since each of these fields spans a wide range of topics, we focused our literature review in two basic ways. First, we concentrated on studies and theories that related most directly to the kinds of dependent variables (attitudinal and behavioral effects) described in the literature on arts benefits. For attitudinal change, we thus targeted studies examining such effects as increases in self-discipline, motivation, self-efficacy, and tolerance. And for behavioral change, we targeted studies that looked at the determinants of school attendance and dropout rates, teamwork, inter-

[2] There is some debate within the social psychology literature about whether self-efficacy is restricted to a specific domain (e.g., to a particular art form, such as dancing) or affects the individual more generally.

personal skills, community service, and pro-social behavior among youth, including drug and alcohol addiction and delinquency. Second, we attempted to identify studies that emphasize independent variables (those that determine attitudinal or behavioral change) linked to factors described in the benefits literature, such as attachment to school, motivation to do well in school, self-discipline, and learning the value of self-criticism. Thus, we paid special attention to theories of attitudinal and behavioral change that mentioned these types of variables.

Key Concepts

A variety of theories are used to explain the dynamic behind attitude formation and behavioral change, yet there is considerable overlap in the concepts that are used in these theories. Mindful of the risk of oversimplification, we chose to categorize these theories in terms of their focus on the interplay (and determinants) of three sets of factors in shaping behavior:

- **Beliefs,** by which we mean either the trust that individuals place in a condition or an object (e.g., that school will provide an opportunity to learn) or the confidence that a particular condition is true (e.g., that the consequence of a behavior will result in a specific outcome).
- **Attitudes,** by which we mean particular states of mind or feelings, (e.g., the desirability of complying with peers) or particular kinds of behavior (e.g., smoking).
- **Intentions,** by which we mean plans to engage (or not to engage) in a particular behavior.

As a general rule, the various theories broadly agree that the sequence behind behavior starts with beliefs, which in turn influence attitudes, which then affect intentions and eventually influence behavior. Where the theories differ is in the importance they attach to these various elements, the factors that determine them, and the role of social versus personal variables in driving behavior.

We identified five different theories that have been used to explain changes in these phenomena:

1. **Social control theory.** This theory assumes that the dominant role in determining behavior is played by the social bonds to conventional society that are formed by associations in family, school, and other conventional settings (e.g., church, community organizations) (Hirshi, 1969; Hawkins and Lishner, 1987). Social bonds are seen as creating a commitment to conventional society and behavior and thus as producing an intention to behave in conformance with conventional standards and norms.

2. **Social learning theory.** This theory stresses the role that associations with significant individuals (be they family members, peers, or others) play in shaping attitudes toward specific behaviors and the expected consequences of those behaviors (Petraitis, Flay, and Miller, 1995; Akers and Lee, 1996). These attitudes are learned (hence the title *social learning theory*) from the individual's interactions with various individuals. Moreover, if individuals are exposed to a variety of conflicting behavioral models and norms, they typically attempt to reach resolution through trial behavior. Thus, an individual's attitudes are reinforced through observation and experience.

3. **Social cognitive theory.** In contrast to the two theories above, which emphasize social influences on attitudes and behavior, social cognitive theory posits a psycho-social model in which both social and personal factors (in particular, self-efficacy) play important roles in determining attitudes and behavior (Bandura, 1977, 1986). Social factors are seen as helping shape attitudes and intentions, but personal factors are seen as being of central importance to the individual's ability to follow through on intentions. Personal factors come into play in this theory in two ways: the individual's personal skills and interests (1) help shape his or her perceptions of the lessons he or she draws from the social influences and (2) affect his or her ability to translate these beliefs into behavioral intentions and then to act on these intentions.

4. **Theory of planned behavior.** This theory (Azjen, 1991) builds on Bandura's concept of self-efficacy and, like Bandura, assumes that individual intentions in combination with self-efficacy are the proximate determinants of behavior. This theory, however, places more emphasis on the role that past experiences and social norms play in shaping attitudes toward specific behaviors and intentions to perform those behaviors.

5. **Social development model.** This model combines elements of social control theory and social learning theory. Like social control theory, it recognizes the importance of strong social bonds in influencing attitudes and behavior; like social learning theory, it recognizes the lessons people draw from their associations with others. The importance of various social bonds and experiences, however, is assumed to vary with the individual's level of development. In the early stages of development, family associations are the most important; then, as the child matures, school associations and peer groups become the critical factors. This model also posits three necessary conditions for the development of positive social bonds: one must have the opportunity to be involved with the activity, one must have the skills needed to perform competently in the activity, and one must receive positive reinforcement.

Despite their differences in emphasis, these theories identify three key concepts that can be used to clarify the mechanisms through which the arts might generate

attitudinal and behavioral benefits. First, behavioral change is not produced by a single activity or influence, but through a process linking experience and relationships to beliefs and attitudes that help form intentions and, eventually, behavior. Second, this process involves a dynamic that begins with the activities, associations, and experiences that shape an individual's beliefs and attitudes, which are central to the formation of intentions that influence behavior. Third, this process involves the interplay of both social and personal factors.

These theories underscore the importance of social bonds and associations to attitudinal and behavioral change. Associations promote positive attitudes and behavior in individuals in four ways: They aid the identification and inculcation of norms of what constitutes acceptable and desirable behavior, they provide role models of appropriate and inappropriate attitudes and behavior, they provide examples of the consequences of specific behaviors, and they can provide powerful motivations for behaving in specific ways to comply with the wishes and standards of peers and others.

In addition to underscoring the importance of personal experience in forming attitudes and behavior, these theories underscore the development of such personal intellectual and behavioral skills as forethought, self-reflection, critical thinking, and self-regulation in shaping attitudes and behavior. In particular, the literature recognizes the central role that perceived self-efficacy plays in changing attitudes and behavior.

Insights on Community-Level Social Benefits

Typically, when arts advocates refer to the community-level benefits of the arts, they are referring to economic benefits. This reflects the broad recognition among policymakers of the importance of economic growth and development to the public interest. However, it also reflects the much less developed state of both the empirical and the theoretical literature on community development. Indeed, although rich in potentially useful concepts, the literature on community social benefits lacks a comprehensive theoretical approach. Instead, empirical studies of community-level social benefits tend to focus either on how the arts can build a sense of community or on how arts-related activities can help build a capacity for collective action.

Because of this typical separation into two topics, it is difficult to develop a comprehensive treatment of how the arts can promote social benefits at the community level. To reflect the diverse disciplinary approaches to these two topics, we reviewed studies from various disciplines: (1) sociological literature on social cohesion, social solidarity, and social capital; (2) social and community psychology literature on measures of social capital and collective efficacy; (3) community development literature on mobilization of communities; (4) public health literature on the role social

capital plays in community well-being; (5) literature on social cohesion, community identity, and social control and their role in the quality of community life; (6) studies from the urban anthropology literature on the role of community capital; (7) political science studies of social capital and its role in civic culture and nongovernmental organizations; (8)economic development studies examining the role of social capital in third-world development.[3]

Key Concepts

Because the conceptual discussion is fragmented across disciplines, our discussion here is organized around the two categories of social benefits claimed in the empirical literature and discussed in Chapter Two: (1) building a sense of community and (2) building a capacity for collective action. Within each of these categories, we identify a series of key concepts that can contribute to an understanding of how the arts can produce social benefits at the community level. We then attempt to show how these two different perspectives can be integrated to develop a more general framework for analyzing the social benefits of the arts to communities.

Building a Sense of Community. The concept of *social capital* is central to the many literatures on community. Although this concept is defined in various ways (Granovetter, 1973; Coleman, 1988, 1990; Putnam, 1993, 2000; Portes, 1998; Fukuyama, 2001), we see it as the connections, including networks, among individuals that engender trust and norms of reciprocity, and the benefits that accrue to the members of a community as a result of these connections. Social capital is described

[3] This array of disciplines is indicative of the heightened interest in what makes a community capable, effective, or healthy. There is also an interest in the effect that feelings of community and community's actual existence have on individual and community outcomes, such as public safety, avoiding risky behaviors, civic participation, and effective governance. In recent years, issues of community have benefited from new attention, methodologies, and theories stemming from the realization that the traditional models and explanations for outcomes do not fully explain what is happening in communities. There is an increasing appreciation for the "social" aspects of community and the need for "social" solutions, possibly outside the public policy sphere. This interest is also motivated by current concern about the decline of civic engagement and social cohesion throughout the socioeconomic spectrum (as indicated by the willingness to help others, voting, joining organizations) and at every level of community (neighborhood, local town, civic society). This sense of civic crisis has combined with the realization that socially connected and civically engaged communities exhibit more successful outcomes in education, urban poverty, unemployment, health, crime, and drug abuse to focus many academics, policy experts, and intellectual leaders on issues of community. A few of the most notable works in this wide array of literature are James Coleman's *Foundations of Social Theory* (1990); Mark Granovetter's "The Strength of Weak Ties" (1973); Robert Putnam's *Bowling Alone: The Collapse and Revival of American Community* (2000); Penelope Hawe and Alan Shiell's "Social Capital and Health Promotion: A Review" (2000); Sarah Hean et al.'s "The 'M-C-M' Cycle and Social Capital" (2003); Michael Hogg's *The Social Psychology of Group Cohesiveness: From Attraction to Group Identity* (1992); Kimberly Lochner, Ichiro Kawachi, and Bruce P. Kennedy's "Social Capital: A Guide to Its Measurement" (1999); Robert J. Sampson, Stephen W. Raudenbush, and Felton Earls's "Neighborhoods and Violent Crime: A Multilevel Study of Collective Efficacy" (1997); Marcel Fafchamps's *Social Capital and Development* (2002); Francis Fukuyama's "Social Capital, Civil Society and Development" (2001); Christiaan Grootaert and Thierry van Bastelaer's *The Role of Social Capital in Development: An Empirical Assessment* (2002); Thomas Wolff's "Community Coalition Building—Contemporary Practice and Research" (2001).

as a key *outcome* of communities that have developed cohesion, as well as a key *input* for collective action.

Putnam (2000) points out that the formation of social capital begins with social interaction that converts people from being a collection of atomistic individuals into members of a community. Whether the interaction is triggered by a common interest (such as the love of classical music or having children in the same school) or is more random, it can provide an opportunity for common interests to be recognized and "loose linkages" to be formed (Durkheim, 1933). This combination of shared interests and repeated opportunities for social interaction allows people to discover additional connections, which can create social links.

Social links typically take two forms, defined in the literature as *bonds* and *bridges* (Coleman, 1990; Putnam, 2000). Bonds are links that tie individuals together on the basis of homogeneity—around shared demographics (e.g., socioeconomic or ethnic status), sense of purpose (e.g., membership in a gang) or social identity (e.g., college or professional affiliation). Bridges are links that form across social divides—for example, belonging to a group whose membership spans sociodemographic or professional affiliations. These two types of associations, bonds and bridges, can promote a sense of shared interest and can lead to feelings of trust and expectations of reciprocity—necessary ingredients for building social capital.

The roots of the sense of trust that develops can be either personalized (formed through repeated personal interaction) or generalized (formed at a distance through knowledge of common interests or backgrounds, or through common membership in groups such as professional and alumni associations) (Coleman, 1990; Putnam, 2000). Trust based on personalized ties usually develops over time, involves considerable effort, and is resilient; trust based on generalized ties is established more quickly, does not require much interaction, and is less resilient. Regardless of how the trust is formed, however, it helps create a sense of community identity and social cohesion.

This *social cohesion* not only builds a sense of community, it also can influence the attitudes of the group's members in a variety of ways.[4] It may, for example, undercut stereotypes and promote personalized trust. It can also affect the willingness of the group's members to cross social divides, and it can increase their tolerance of differences (for example, when cooperation must be maintained in pursuing common goals that are mutually beneficial). So, too, can this social cohesion and sense of community identity promote a distinction between those inside the group and those

[4] We draw a distinction between attitudinal change in the community context and attitudinal change in the individual context. Our discussion of the latter (see earlier section in this appendix) focuses on those individual attitudes that benefit the individual either in terms of his or her ability to do well in school or to cope with problems faced in his or her particular life situation. Our discussion here, of attitudinal change in the community context, focuses on the attitudes that socialize people or help them work collectively (e.g., tolerance, community pride, bonds of trust, reciprocity with others). Although the processes that give rise to all of these attitudinal changes are similar, there is a difference in the level of benefits to which they apply.

outside of it. This distinction can, in turn, lead to the group's pursuit of its own interests at the expense of the wider community's interests (Portes and Landholt, 1996). Social cohesion based on bridges, or links that cross differences, is more conducive to positive attitudes; whereas social cohesion based on bonds, or links based on homogeneity, is more likely to result in the pursuit of narrow interests (Putnam, 2000).

Once social cohesion forms, it does more than create a sphere of social life and identity within the community; it also influences the willingness of community members to act for the common good. Such action may take the form of *informal social control* as community members exercise sanctions against behaviors that might threaten the community interest (e.g., criminal activity), and/or it may take the form of promotion of the community's interests (e.g., upgrading of the community's physical image or securing of increased resources). To the extent that such efforts are successful, they may produce a sense of *collective efficacy*—that is, a belief in the community's own ability to make a concerted and successful response to a specific challenge or opportunity.

In combination, these concepts or processes—social cohesion, informal social control, collective efficacy—are instrumental in developing a sense of *community sentiment*, which we take to mean the aggregated attitudes of individuals in a community about the existence of social supports and networks. This includes, for example, individuals' sense of being part of a group, of connectedness and shared history, of individuals mattering to the group, and of the group being capable of influencing its members through shared social norms.

Building a Capacity for Collective Action. The empirical arguments for collective social benefits primarily focus on how the arts can build social capital. However, the community level effects of the arts on communities are broader than this; indeed, we believe that the ways in which involvement with the arts can promote community development at a broader level are more important than they have been given credit for. These broader social benefits merit greater attention because they accrue not just to those involved in the arts, but also to those not involved in the arts. Moreover, a variety of concepts in the theoretical literature can help explain how these benefits are created. These concepts can build on the arts benefits literature on social capital.

Specifically, the discussion above highlights the fact that the initial steps in building a capacity for collective action entail the establishment of interactions among community residents, which can then lead to social ties (bonds and bridges), a sense of common identity, and social cohesion—all precursors to social capital. The more interrelated these networks (neighborhood associations, sports clubs, other forms of association), the greater the levels of trust and reciprocity among community members, and thus the more likely that community members will overcome the obstacles to collective action.

This capacity for collective action may initially be applied to dealing with specific community issues, but may then continue beyond that specific agenda, thus giving rise to *community coalitions*. Coleman (1990), for example, discusses a coalition in an urban housing project that was initially formed to pressure builders to fix leaks, crumbling sidewalks, and other items needing repair. After accomplishing what it had formed to accomplish, it remained in place and later joined with other community groups to obtain other improvements in their quality of life. Community mobilization is important in this context in that successful collaboration in one area builds connections and trust and can facilitate collaboration on other, unrelated endeavors.

Two elements central to developing this kind of community mobilization are the development of local leaders and the development of organizational skills and assets, since they help to channel collective action of community members toward a specific issue. They are typically essential to building cross-sector cooperation among different groups for sustaining this community mobilization. Over time, this type of community mobilization and collective action can facilitate *community revitalization*, but this outcome requires long-term cross-sector cooperation. Moreover, it requires the sustained operation of a variety of other economic, political, and social processes over time.

Integrating These Concepts. Although studies of how this process of building a capacity for collective action occurs tend to focus on specific communities, it seems that the process may have application for civil society more generally. Indeed, this type of community mobilization and revitalization is in part motivated by a desire to reverse a growing disaffection of citizens for their public institutions and a desire to move away from top-down governmental control of community life to a more grassroots (bottom-up) community action.

The concepts we have described are typically discussed in piecemeal fashion in different studies, rather than as part of a theory of community revitalization, but our synthesis of these concepts suggests a framework for building such a theory. We see this process as involving three distinct parts, or stages, as illustrated in Figure A.1. The first stage involves the development of social capital. It begins with the promotion of social interaction that leads first to the formation of social cohesion through bonds and bridges and then to the formation of social capital. Social capital is both an output of the increasing social cohesion and community identity at the community level (stage 1) and an input to the second stage of the process: the development of the organizational and leadership skills that seem to be required for building successful community coalitions and other forms of more structured collective action. The final stage of the process, community revitalization, requires a more advanced form of collective action entailing sustained intergroup cooperation and more intense and long-term forms of civic engagement, and involves economic and political as well as social processes.

Figure A.1
Building Vital Communities from the Bottom Up: A Hierarchy of Capacities

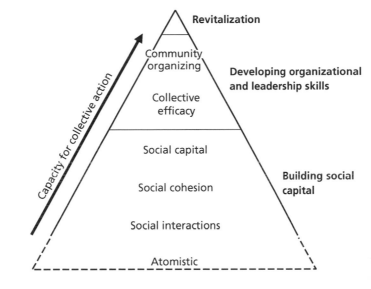

RAND *MG218-A.1*

Although the framework represented by this pyramid is not a fully fleshed-out theory in the sense of specifying the determinants of the subprocesses that operate at each stage of the process, it does suggest how the various concepts we have described might be related to one another. It also indicates how the challenges facing a community are likely to grow more difficult as the community moves up the pyramid; that is, fostering social interaction and building social cohesion are likely to be less difficult than mobilizing community associations for collective action in pursuit of a specific goal, which, in turn, will be less difficult than building collaboration across groups and issues and sustaining this cooperation over time.

Significant social benefits can be recognized at each stage of the process. Each stage is important in and of itself, and one stage will not necessarily lead to the next (nor necessarily should it); but each stage must be built on the stages beneath it. What the framework offers is a theoretically grounded structure for relating the various categories of social benefits described in the empirical literature both to one another and to a common community-level process.

Theoretical Insights on Economic Benefits

The empirical literature on the economic benefits of the arts, unlike the literature on the other categories of benefits, builds on a relatively well-established base of theory. This is true in two senses. First, the economics literature, perhaps more so than the

rest of the social sciences literature, in general has a well-developed body of general theories to explain broad classes of economic phenomena, including many of the types of benefits cited in the arts literature. The theory of general equilibrium, although designed to explain the workings of the economy as a whole, can be applied to explain the relationship between the arts as an industry and the rest of a local economy. Similarly, there are economic models that are designed to explain economic development, the workings of urban economies, and the phenomenon of public goods. Second, unlike the general theories of other disciplines, the economics general theories have also been applied to the realm of arts and culture within the subdiscipline of cultural economics. As a result, in addition to building on a body of work that has already developed the application of economic theory to the arts, the literature on the economic benefits of the arts has amassed the measurement tools, methodological approaches, and subsequent refinements of each of these components of analysis.

In light of this situation, we concentrated our review of the economic literature not on works discussing general economic theories, but on studies that have applied those general theories and techniques to the cultural sector. This body of literature includes: (1) studies of the role that the arts as an industry play in the local economy (including studies of the multiplier effects of the arts industry), (2) studies of how the presence of the arts promotes local economic development by attracting selective classes of workers and firms, and (3) studies of the nonfinancial benefits of the arts (the arts as a public good). In addition to reviewing these theoretical studies, we reviewed articles on various measurement approaches and articles critiquing the existing work.[5]

Key Concepts[6]

As discussed in Chapter Two, the empirical benefits literature discusses three different categories of economic benefits: those that result directly from the arts as a source of employment, spending, and tax revenues; those that result from the arts' attractiveness to individuals and firms; and those that relate to the broader, nonfinancial benefits that the arts can bring to a community and its residents.

The literature on the direct economic benefits of the arts focuses on the role the arts play in the operation of a local economy (see Figure A.2). From this perspective,

[5] See, for example, Deasy, 2002; Weitz, 1996. Also see RAND reports on prosocial effects: McArthur and Law, 1996; Ann Stone et al., 1997, 1999.

[6] This review focuses on the instrumental economic benefits of the arts. Economists, however, have also examined other aspects of the arts. Stigler and Becker (1977), for example, employ economic models to explain why individuals' taste for the arts can increase with greater familiarity and competence. Scitovosky (1992) and others draw a distinction between comfort and creative goods to suggest that the nature of consumption of creative goods (the arts) differs from that of comfort goods. Finally, Throsby (2004) suggests that in addition to their economic benefits, the arts can provide cultural value to a society.

the arts are important both as a source of demand for arts products and as a source of employment for local workers. Individual consumers' demand for the arts, for example, stimulates art organizations and commercial firms to meet that demand. These entities, in turn, employ and pay a range of employees (both artists and others who have the wide range of skills needed to manage and run arts organizations). This interplay of supply and demand extends beyond the arts consumers and arts organizations, however, since arts consumers often purchase a range of non-arts goods and services (such as lodging, food, parking, childcare) in the process of consuming the arts—just as arts organizations purchase a range of non-arts goods and services (such as advertising, office supplies, accounting services) as part of their role in supplying arts goods and services. Moreover, because arts organizations and their employees pay sales taxes on their purchases and income taxes on their earnings, they contribute to government revenues as well.

The economic effects of local arts activities are not limited to direct contributions to the consumption of arts products and to the employment generated by arts firms, however. They also show up as secondary contributions to the local economy through the "multiplier effect," which refers to induced, or spillover, benefits resulting from the additional (non-arts) economic activity (jobs and purchases) produced by economic activity in the arts sector. Employees of arts organizations, as well as the arts organizations themselves, purchase a variety of non-arts goods and services,

Figure A.2
How the Arts Create Direct Economic Benefits

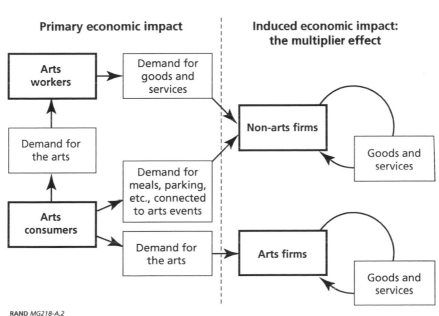

which results in more spending and more jobs in the economy overall. Thus, the arts sector benefits the local economy through employment and purchases in the arts sector *and* it produces a secondary effect through its role in stimulating economic activity in the non-arts sector. In other words, the arts produce economic benefits not only for those who are directly involved in the arts as producers or consumers, but also for those who are not directly involved in the arts—through the multiplier effect. The magnitude of these benefits, and thus the arts contribution to the local economy as a whole, depends on the size of the multiplier effect.

There are two controversies related to the multiplier concept. First, there is the question of the size of the produced effect for the arts compared to the effect produced by other activities—that is, how much "bang for the buck" is generated by direct spending on the arts (such as constructing a new performing arts center), as opposed to some other investment project (such as building a new sports stadium or expanding a local airport). Unfortunately, this question is often ignored in economics studies of the arts industry. The second controversy focuses on whether direct consumer spending on the arts represents an *addition* to total spending or merely a *substitute* for spending that would otherwise be directed to other types of goods and services (meals eaten out, attendance at sports events, and other types of discretionary activities). In general, the literature suggests that the higher the fraction of total arts spending that comes from tourists or other visitors to a local area, the more that spending will represent an addition to the local economy. Thus, local communities whose arts infrastructure attracts visitors from outside the local area will have higher multiplier effects. Some studies have noted that economies with major arts attractions, such as New York City, benefit more from their arts industries than other communities do, but the research on this topic is scant at this point.

There is some disagreement among economists about these two issues. Some economists believe, for example, that failing to compare the relative size of the multiplier effect for arts-related versus other activities is tantamount to implicitly assuming that the multiplier for these other activities is zero. Correspondingly, they argue that most economic impact analyses are really examining the gross effect of arts-related activities, whereas the appropriate measure is the net effect, which would explicitly consider the economic effects of the arts versus other economic activities. Others suggest that virtually all of the additional spending induced by expenditures on the arts merely substitutes for expenditures that would have occurred in any case. From their perspective, the appropriate way to assess the direct effects of the arts is to ignore the multiplier effect.

The literature on the indirect benefits of the arts focuses less on the operation of the arts industry in a local economy than on the attraction that arts and culture hold for particular types of consumers. The underlying premise of this approach to economic benefits is the assumption that highly skilled and well-educated workers are attracted to local economies, principally cities, that offer interesting arts opportuni-

ties (Figure A.3 illustrates this process). Since such workers are much sought after by the types of firms that local communities desire to attract (e.g., firms that pay high salaries, are often environmentally clean, and add prestige to the local economy), a strong arts community can promote local economic development. Moreover, this dynamic compounds itself in that the highly skilled workers will consume the arts, and the high-value firms will support the arts to continue being able to attract these kinds of workers. The net effect, therefore, is that a healthy arts sector helps trigger a virtuous cycle of economic growth: The arts sector attracts the types of workers who spend money on the arts and pay taxes, and these workers are the ones that desirable firms (which create good jobs and pay taxes) need in order to prosper.

The cultural economics literature does not limit itself solely to the direct and indirect economic benefits of the arts by focusing on the types of quantitative economic benefits that result from increased employment and spending, higher tax revenues, and the ability of the arts to attract particular types of firms and workers and thus promote local economic development. There is currently a whole branch of cultural economics literature that focuses on what we have described above as "public-good" benefits. Although such benefits are, by their very nature, difficult to measure, and their magnitude is thus a subject of considerable debate, they are nonetheless a class of advantages that both individuals and the public at large can enjoy simply because the arts are present in their communities.[7] As we noted in Chapter Two, this set of nonfinancial benefits includes both the value people place on knowing the arts exist and are being preserved even if those people do not actually partici-

Figure A.3
How the Arts Create Indirect Economic Benefits

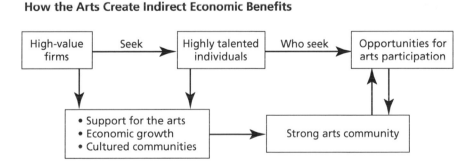

SOURCES: Arora et al., 2000; Florida, 2000.
RAND *MG218-A.3*

[7] Economists have devoted considerable attention in recent years to developing techniques for measuring such benefits. These techniques include contingent valuation (willingness to pay), hedonic approaches, and the time individuals spend in traveling to the arts. The contingent valuation approach, especially as applied to environmental economics, has become well established.

pate in the arts (referred to as *existence value*) and the value people place on having the arts available should they choose to participate in them in the future (referred to as *option value*). Corresponding to these present and future benefits are the prestige and edification that the arts can provide to communities and the importance people attach to having the arts available for future generations (referred to as *bequest value*). In the case of these public-good benefits, the cultural economics literature assumes that despite the difficulty of measuring them, they are valued by individuals and communities. Indeed, as we noted above, a whole component of this literature is devoted to various approaches to assigning a monetary value to such benefits.

Bibliography

Ajzen, I., "The Theory of Planned Behavior," *Organizational Behavior and Human Decision Processes*, 50:179–211, 1991.

————, "From Intentions to Actions: A Theory of Planned Behavior," in J. Kuhl and J. Beckmann (eds.), *Springer Series in Social Psychology, Action Control from Cognition to Behavior*, Berlin Heidelberg: Springer-Verlag, 1985.

Ajzen, I., and T.J. Madden, "Prediction of Goal-Directed Behavior: Attitudes, Intentions, and Perceived Behavioral Control," *Journal of Experimental Social Psychology*, 22:453–474, 1986.

Akers, R.L., and G. Lee, "A Longitudinal Test of Social Learning Theory: Adolescent Smoking," *Journal of Drug Issues*, 26(2):317–343, 1996.

American Assembly, *The Arts and the Public Purpose*, final report of the 92nd American Assembly, New York: American Assembly, Columbia University, pp. 64–70, 1997.

————, "Highlights from a Nationwide Survey of the Attitudes of the American People Toward the Arts," Vol. 7, prepared for the American Council for the Arts, The National Assembly of Local Arts Agencies, conducted by Louis Harris, 1996.

Americans for the Arts, *National Arts Education Public Awareness Campaign Survey: Americans' Beliefs About the Importance of Arts Education*, 2001.

Arora, Ashish, Richard Florida, Gary Gates, and Mark Kamlet, "Human Capital, Quality of Place and Location," working paper, Pittsburgh, PA: Carnegie Mellon University, September 2000.

Arts Education Partnership, *Gaining the Arts Advantage: Lessons from School Districts That Value Arts Education*, 1999.

Baade, Robert, "Some Observations of Analyzing Economic Impacts: A Case Study," paper prepared for Lasting Effects: Assessing the Future of Economic Impact Analysis Conference, Tarrytown, NY, May 2004.

Bandura, Albert (ed.), *Self-Efficacy in Changing Societies*, Cambridge, UK: Cambridge University Press, 1995.

Bandura, Albert, *Social Foundations of Thought and Action: A Social Cognitive Theory*, Englewood Cliffs, NJ: Prentice-Hall, Inc., 1986.

————, "Self-Efficacy: Toward a Unifying Theory of Behavior Change," *Psychological Review*, 84:191–215, 1977.

Belfiore, Eleonora, "Art as a Means of Alleviating Social Exclusion: Does It Really Work?" *International Journal of Cultural Policy*, 8(1):91–106, 2002.

Benedict, Stephen, *Public Money and the Muse: Essays on Government Funding for the Arts*, W.W. Norton and Company, May 1991.

Bergonzi, Louis, and Julia Smith, *Effects of Arts Education on Participation in the Arts*, Washington, DC: National Endowment for the Arts, 1996.

Bergson, Henri, "The Individual and the Type" (from *Laughter*, 1909, trans. 1913), in Melvin Rader (ed.), *A Modern Book of Esthetics: An Anthology*, 3rd edition, New York: Holt, Rinehart and Winston, 1961 [©1935], pp. 80-87.

Bianchi, Marina, "Novelty, Preferences, and Fashion: When Goods Are Unsettling," *Journal of Economic Behavior and Organization*, 47:1–18, 2002.

Bianchini, Franco, "Remaking European Cities: The Role of Cultural Policies," in Franco Bianchini and Michael Parkinson (eds.), *Cultural Policy and Urban Regeneration*, New York: Manchester University Press, pp.1–20, 1993.

Booth, Wayne, *The Company We Keep: An Ethics of Fiction*, Berkeley and Los Angeles, CA: University of California Press, 1988.

Bourdieu, Pierre, *Distinction: A Social Critique of the Judgment of Taste*, Cambridge, MA: Harvard University Press, 1984.

Bowles, Samuel, and Herbert Gintis, "Social Capital and Community Governance," *The Economic Journal*, 112(483):419–436, November 2002.

Bransford, John D., *Human Cognition: Learning, Understanding and Remembering*, Belmont, CA: Wadsworth Publishing Company, 1979.

Brooks, Arthur C., and Roland J. Kushner, "Cultural Policy and Urban Development, *International Journal of Arts Management*, 3(2):4–15, 2001.

Bruner, Jerome, *Actual Minds, Possible Worlds*, Cambridge, MA: Harvard University Press, 1986.

Budd, Malcolm, *Values of Art*, London: Penguin Books, 1995.

California Arts Council, *Current Research in Arts Education: An Arts in Education Research Compendium*, by ARTS, Inc., Los Angeles, 2001.

Carroll, Noel, *Beyond Aesthetics: Philosophical Essays*, Cambridge, MA: Cambridge University Press, 2001.

Cassirer, Ernst, "The Educational Value of Art" [1943], in Donald Phillip Verene (ed.), *Symbol, Myth, and Culture: Essays and Lectures of Ernst Cassirer, 1935–1945*, New Haven, CT: Yale University Press, 1979, pp. 196–215.

Catterall, James S., "Involvement in the Arts and Human Development: General Involvement and Intensive Involvement in Music and Theatre Arts," *Champions of Change*, 1999.

———, "Risk and Resilience in Student Transitions," *American Journal of Education*, 106(2):302–332, 1998.

———, "The Arts and Success in Secondary School," *Americans for the Arts*, 1(9):1–10, 1997.

———, "Does Experience in the Arts Boost Academic Achievement?" *Art Education*, September 1997.

———, *Different Ways of Knowing: 1991–1994 National Longitudinal Study Final Report*, Tempe, AZ: Morrison Institute of Public Policy and the National Endowment for the Arts, 1995.

Cavell, Stanley, *Must We Mean What We Say?* [1969], New York: Cambridge University Press, 2002.

Ciment, Michel, and Laurence Kardish, *Positif 50 Years: Selections from the French Film Journal*, The Museum of Modern Art, New York, 2003.

Coleman, James, *Foundations of Social Theory*, Cambridge, MA: Harvard University Press, 1990.

———, "Social Capital and the Creation of Human Capital," *American Journal of Sociology*, 94:S95–120, 1988.

Coles, Robert, *The Call of Stories*, Boston, MA: Houghton Mifflin Company, 1989.

Community Survey Questionnaire, Project on Human Development in Chicago Neighborhoods, 1994.

Csikszentmihalyi, Mihaly, *Creativity: Flow and the Psychology of Discovery and Invention*, New York: HarperCollins Publishers, 1997.

———, *The Evolving Self: A Psychology for the Third Millennium*, New York: HarperCollins Publishers, 1993.

———, *Flow: The Psychology of Optimal Experience*, New York: HarperCollins Publishers, 1990.

———, *Being Adolescent*, Basic Books Inc., 1984.

Cuno, James (ed.), *Whose Muse? Art Museums and the Public Trust*, Princeton, NJ: Princeton University Press, and Cambridge, MA: Harvard University Art Museums, 2004.

D'Andrade, Roy, *Development of Cognitive Anthropology*, Cambridge, MA: Cambridge University Press, 1995.

Deasy, Richard, *Critical Links: Learning in the Arts and Student Academic and Social Development*, Washington, DC: Arts Education Partnership, 2002.

Dewey, John, *Art as Experience* [1934], New York: The Berkeley Publishing Company, Perigee Books, 1980.

———, *Experience and Education* [1938], New York: First Touchstone Edition, 1997.

Dickie, George, Richard Scalafani, and Ronald Roblin, *Aesthetics: A Critical Anthology*, 2nd edition, New York: St. Martin's Press, 1989.

DiMaggio, Paul, "Are Museum Visitors Different from Other People? The Relationship Between Attendance and Social and Political Attitudes in the United States," *Poetics*, 24:161–180, 1996.

———, "Taking the Measure of Culture: A Meeting at Princeton University, June 7–June 8, 2002," meeting prospectus, http://www.Princeton.edu/~artspol/moc_prospectus.html, 2002.

DiMaggio, Paul, and Becky Pettit, "Surveys of Public Attitudes Toward the Arts: What Surveys Tell Us About the Arts' Political Trials—and How They Might Tell Us Even More," *Arts Education Policy Review*, 100(4):32–37, March/April 1999.

Dissanayake, Ellen, *Homo Aestheticus: Where Art Comes From and Why*, Seattle, WA: University of Washington Press, 1992.

Durkheim, Emile, *The Division of Labor in Society*, New York: Free Press, 1933.

Earls, Felton, *Project on Human Development in Chicago Neighborhoods: Community Survey, 1994–1995*, Inter-University Consortium for Political and Social Research, National Institute of Justice, 1999.

Eisner, Elliot, "Ten Lessons the Arts Teach," presented at Learning and the Arts: Crossing Boundaries Conference, January 2000.

———, "Does Experience in the Arts Boost Academic Achievement?" *Arts Education Policy Review*, 100(1):32–37, 1998.

Eliot, T.S., *The Four Quartets: East Coker*, Sec. 2, 1943.

Elliott, D.S., D. Huizinga, and S.S. Ageton, *Explaining Delinquency and Drug Use*, Beverly Hills, CA: Sage Publications, 1989.

Elliott, D.S., D. Huizinga, and S. Menard, *Multiple Problem Youth: Delinquency, Substance Use, and Mental Health Problems—from Research in Criminology*, New York: Springer-Verlag, 1989.

Epstein, Richard, A., "The Regrettable Necessity of Contingent Valuation," *Journal of Cultural Economics*, 27:259–274, 2003.

Fafchamps, Marcel, *Social Capital and Development*, England: University of Oxford, Department of Economics, 2002.

Falk, John H., and John D. Balling, "The Field Trip Milieu: Learning and Behavior as a Function of Contextual Events," *Journal of Educational Research*, 76(1):22–28, 1982.

Fisher, Philip, *Wonder, the Rainbow, and the Aesthetics of Rare Experiences*, Cambridge, MA, and London: Harvard University Press, 1998.

Fiske, Edward (ed.), *Champions of Change: The Impact of the Arts on Learning*, Arts Education Partnership and President's Committee on the Arts and the Humanities, 1999.

Fleischacker, Samuel, *A Third Concept of Liberty: Judgment and Freedom in Kant and Adam Smith*, Princeton, NJ: Princeton University Press, 1999.

Florida, Richard, "Competing in the Age of Talent," working paper, Pittsburgh, PA: Carnegie Mellon University, 2000.

———, *The Rise of the Creative Class*, New York: Basic Books, 2002.

Ford Foundation, *The Finances of the Performing Arts*, Vol. 2, New York: The Ford Foundation, 1974.

Frey, Bruno S., "Evaluating Cultural Property: The Economic Approach" *International Journal of Cultural Property*, 6(2):231–246, 1997.

Fromm, Erich, *The Sane Society*, New York: Rinehart and Company, Ltd., 1955.

Frumkin, Peter, *On Being Nonprofit: A Conceptual Policy Primer*, Cambridge, MA: Harvard University Press, 2002.

Fukuyama, Francis, "Social Capital, Civil Society and Development," *Third World Quarterly*, 22(1):7–20, 2001.

———, *Trust: The Social Virtues and the Creation of Prosperity*, New York: Free Press, 1995.

Gapinski, James H., "The Lively Arts as Substitutes for the Lively Arts," *The American Economic Review*, 76(2):20–25, 1986.

Gardner, Howard, *Intelligence Reframed: Multiple Intelligences for the 21st Century*, New York: Basic Books, 1999.

———, *The Unschooled Mind: How Children Think and How Schools Should Teach*, New York: Basic Books, 1991.

———, *Art Education and Human Development*, J. Paul Getty Center for Education in the Arts, 1990.

———, "Zero-Based Arts Education: An Introduction to ARTS PROPEL," *Studies in Art Education Journal of Issues and Research*, 30(2):71–83, 1989.

Gobe, Marc, *Emotional Branding: The New Paradigm for Connecting Brands to People*, New York: Alworth Press, 2001.

Goldman, Alan H., *Aesthetic Value*, Boulder, CO: Westview Press, 1995.

Granovetter, Mark S., "The Strength of Weak Ties," *American Journal of Sociology*, 78(6):1360–1378, May 1973.

Griffiths, Ron, "The Politics of Cultural Policy in Urban Regeneration Strategies," *Policy and Politics*, 21(1):39–46, 1993.

Grootaert, Christiaan, and Thierry van Bastelaer (eds.), *The Role of Social Capital in Development: An Empirical Assessment*, Cambridge, UK: Cambridge University Press, 2002.

Guetzkow, Joshua, "How the Arts Impact Communities: An Introduction to the Literature on Arts Impact Studies," *Working Paper Series*, No. 20, Princeton University, June 2002.

Hamblem, Karen A., "Theories and Research That Support Art Instruction for Instrumental Outcomes," *Theory Into Practice*, 32(4):191–198, 1993.

Hansen, Trine Bille, "The Willingness-to-Pay for the Royal Theatre Copenhagen as a Public Good," *Journal of Cultural Economics*, 21:1–28, 1997.

Harris, Louis, "Americans and the Arts," Highlights from a Nationwide Survey of the Attitudes of the American People Towards the Arts, American Council for the Arts, June 1996.

Hartman, Geoffrey, *Scars of the Spirit: The Struggle Against Inauthenticity*, New York: Palgrave Macmillan, 2002.

Hawe, Penelope, and Alan Shiell, "Social Capital and Health Promotion: A Review," *Social Science and Medicine*, 51:871–885, 2000.

Hawkins, J.D., and D.M. Lishner, "School and Delinquency," Chapter 8 in *Handbook on Crime and Delinquency Prevention*, New York: Greenwood Press, 1987.

Hawkins, J.D., and J.G. Weis, "The Social Development Model: An Integrated Approach to Delinquency Prevention," *Journal of Primary Prevention*, 6(2):73–97, 1985.

Hean, Sarah, et al., "The 'M-C-M' Cycle and Social Capital," *Social Science and Medicine*, 56:1061–1072, 2003.

Heath, Shirley Brice, with Adelma Roach, "Imaginative Actuality: Learning in the Arts During the Nonschool Hours," in Edward Fiske (ed.), *Champions of Change: The Impact of the Arts on Learning*, Arts Education Partnership and the President's Committee on the Arts and the Humanities, 1999.

Heber, Lou, "Dance Movement: A Therapeutic Program for Psychiatric Clients," *Perspectives in Psychiatric Care*, 29(2), April–June 1993.

Hirshi, T., *Causes of Delinquency*, Berkeley and Los Angeles, CA: University of California Press, 1969.

Hogg, Michael A., *The Social Psychology of Group Cohesiveness: From Attraction to Group Identity*, New York: New York University Press, 1992.

Jackson, Maria-Rosario, "Arts and Culture Indicators in Community Building: Project Update," *Journal of Arts Management Law and Society*, 28:201–205, 1998.

Jackson, Philip W., *John Dewey and the Lessons of Art*, New Haven, CT: Yale University Press, 1998.

James, Miller, and David Read Johnson, "Drama Therapy in the Treatment of Combat-Related Post-Traumatic Stress Disorder, *The Arts in Psychotherapy*, 23(5):383–395, 1997.

Jensen, Joli, *Is Art Good for Us? Beliefs About High Culture in American Life*, Lanham, MD: Rowman & Littlefield Publishers, Inc., 2002.

Journal of Aesthetic Education, Fall/Winter Issue, 2000.

Kant, Immanuel, *The Critique of Judgement*, J.C. Meredith (trans.), Oxford: Oxford University Press, 1952.

Kelly, John R., *Freedom to Be Me: A New Sociology of Leisure*, New York: Macmillan, 1987.

Kelly, John R., and Valeria J. Freysinger, *21st Century Leisure: Current Issues*, Boston, MA: Allyn and Bacon, 2000.

Kopcznski, Mary, Mark Hager, and the Urban Institute, *The Value of the Performing Arts in Five Communities*, The Pew Charitable Trusts, 2003.

Kotkin, Joel, and Ross C. DeVol, *Knowledge-Value Cities in the Digital Age*, Milken Institute, 2001.

Kreidler, John, "Leverage Lost: The Nonprofit Arts in the Post-Ford Era," *Journal of Arts Management, Law and Society*, 26(2)79–100, 1996.

Lange, Mark D., and William A. Luksetich, "Demand Elasticities for Symphony Orchestras," *Journal of Cultural Economics*, 8:29–47, 1984.

Langer, Susanne K., *Problems of Art*, New York: Charles Scribner's Sons, 1957.

Levine, Mel, *A Mind at a Time*, New York: Simon and Schuster, 2002.

Levinson, Jerrold, *The Oxford Handbook of Aesthetics*, Oxford: Oxford University Press, 2003.

———, (ed.), *Aesthetics and Ethics: Essays at the Intersection*, Cambridge, UK, and New York: Cambridge University Press, 1998.

———, *The Pleasures of Aesthetics: Philosophical Essays*, Ithaca and London: Cornell University Press, 1996.

Lochner, Kimberly, Ichiro Kawachi, and Bruce P. Kennedy, "Social Capital: A Guide to Its Measurement," *Health and Place*, 5:259–270, 1999.

Lowe, Seana S., "Creating Community Art for Community Development," *Journal of Contemporary Ethnography*, 29(3):357–386, 2000.

Lowry, Glenn D., "A Deontological Approach to Art Museums and the Public Trust," in James Cuno (ed.), *Whose Muse? Art Museums and the Public Trust*, Princeton, NJ: Princeton University Press, and Cambridge, MA: Harvard University Art Museums, 2004, pp. 129–149.

Macintyre, Alisdair, *After Virtue*, 2nd edition, University of Notre Dame Press, 1984.

Marwick, Charles, "Music Therapists Chime in with Data on Medical Results," *Journal of the American Medical Association*, 283(6):731–733, 2000.

Matarasso, Francois, *Towards a Local Culture Index: Measuring the Cultural Vitality of Communities*, England: Comedia, 1999.

———, *Defining Values: Evaluating Arts Programmes,* England: Comedia, 1996.

McArthur, David, and Sally Law, *The Arts and Prosocial Impact Study: A Review of Current Programs and Literature,* Santa Monica, CA: RAND Corporation, 1996.

McCarthy, Kevin, Arthur Brooks, Julia Lowell, and Laura Zakaras, *The Performing Arts in a New Era*, Santa Monica, CA: RAND Corporation, 2001.

McCarthy, Kevin F., and Kimberly Jinnett, *A New Framework for Building Participation in the Arts*, Santa Monica, CA: RAND Corporation, 2001.

McCarthy, Kevin F., and Elizabeth H. Ondaatje, *From Celluloid to Cyberspace: The Media Arts and the Changing Arts World*, Santa Monica, CA: RAND Corporation, 2002.

McCarthy, Kevin F., Elizabeth H. Ondaatje, and Laura Zakaras, *Guide to the Literature on Participation in the Arts*, Santa Monica, CA: RAND Corporation, 2001.

Meade, George Herbert, *Mind, Self, and Society*, Chicago, IL: University of Chicago Press, 1934.

Merli, Paola, "Evaluating the Social Impact of Participation," *International Journal of Cultural Policy*, 8(1):107–118, 2002.

Miller, George A., "The Magical Number Seven, Plus or Minus Two: Some Limits on Our Capacity for Processing Information," *The Psychological Review*, 63(2):81–97, March, 1956.

Moore, Thomas Gale, "The Demand for Broadway Theatre Tickets," *The Review of Economics and Statistics*, 48(1):79–87, 1966.

Morrison, Bradley G., and Julie Gordon Dalgleish, *Waiting in the Wings: A Larger Audience for the Arts and How to Develop it*, New York: American Council for the Arts, 1987.

Morrison, William G., and Edwin G. West, "Subsidies for the Performing Arts: Evidence on Voter Preference," *Journal of Behavioral Economics*, 15:57–72, 1986.

Munsterberg, Hugo, "Connection in Science and Isolation in Art," (from *The Principles of Art Education*, 1905), in Melvin Rader (ed.), *A Modern Book of Esthetics: An Anthology*, 3rd edition, New York: Holt, Rinehart and Winston, 1961 (©1935), pp. 434–442.

Myerscough, J., *The Economic Importance of the Arts in Great Britain*, London: Policy Studies Institute (1988).

National Assembly of State Arts Agencies (NASAA), *Measuring Your Arts Economy: Twelve Questions and Answers About Economic Impact Studies*, 1997.

National Endowment for the Arts, *2002 Survey of Public Participation in the Arts, NEA Research Division Note 81*, Washington, DC: National Endowment for the Arts, 2003.

————, *1997 Survey of Public Participation in the Arts*, NEA Research Division Report 39, Washington, DC: National Endowment for the Arts, 1998.

Noonan, Douglas, S., "Contingent Valuation and Cultural Resources: A Meta-Analytic Review of the Literature," *Journal of Cultural Economics*, 27:159–176, 2003.

Novak, Joseph D., "Metalearning and Metaknowledge Strategies to Help Students Learn How to Learn," in L.B. Resnick, J.M. Levine, and S.D. Teasley (eds.), *Cognitive Structure and Conceptual Change*, San Diego, CA: Academic Press, 1985.

Nussbaum, Martha C., *Cultivating Humanity: A Classical Defense of Reform in Liberal Education*, Cambridge, MA: Harvard University Press, 1997.

————, *Love's Knowledge: Essays on Philosophy and Literature*, New York, and Oxford, UK: Oxford University Press, 1990.

O'Hare, Michael, and Marisa McNee, "The Second Visit," paper presented at APPAM Research Conference, 2003.

Orend, Richard J., and Carol Keegan, *Education and Arts Participation: A Study of Arts Socialization and Current Arts-Related Activities Using 1982 and 1992 SPPA Data,* Washington, DC: National Endowment for the Arts, 1996.

Peters, Monica, and Joni Maya Cherbo, *Americans; Personal Participation in the Arts: 1992: A Monograph Describing Data from the Survey of Public Participation in the Arts,* Washington, DC: National Endowment for the Arts, 1996.

Petraitis, J., B.R. Flay, and T.Q. Miller, "Reviewing Theories of Adolescent Substance Use: Organizing Pieces in the Puzzle," *Psychological Bulletin,* 117(1):67–86, 1995.

Piaget, Jean, *The Psychology of the Child,* New York: Basic Books, 1969.

———, *The Psychology of Intelligence,* 1st English edition, London, UK: Routledge, Kegan, and Paul, 1950.

Portes, Alejandro, "Social Capital: Its Origins and Applications in Modern Sociology," *Annual Review of Sociology,* 22(1), 1998.

Portes, Alejandro, and Patricia Landholt, "The Downside of Social Capital," *The American Prospect,* 26, 1996.

Putnam, Hilary, "Literature, Science, and Reflection," in *Meaning and the Moral Sciences,* London, UK: Routledge, Kegan, and Paul, pp. 83–96, 1979.

Putnam, Robert D., *Bowling Alone: The Collapse and Revival of American Community,* New York: Touchstone, 2000.

———, *Making Democracy Work: Civic Traditions in Modern Italy,* Princeton, NJ: Princeton University Press, 1993.

Rabkin, Nick, *Learning and the Arts: Crossing Boundaries,* Proceedings from an Invitational Meeting for Education, Arts and Youth Funders, Los Angeles, CA, January 12–14, 2000. Available at http://www.giarts.org/pdf/(as of 25 September 2004).

Rader, Melvin (ed.), *A Modern Book of Esthetics: An Anthology,* 3rd edition, New York: Holt, Rinehart and Winston, 1961.

Radich, Anthony J., *Twenty Years of Economic Impact Studies of the Arts: A Review,* Washington, DC: National Endowment for the Arts, 1992.

Richards, Greg, "The European Cultural Capital Event: Strategic Weapon in the Cultural Arms Race?" *Cultural Policy,* 6(2):159–181, 2000.

Robinson, John P., *Arts Participation in America: 1982–1992,* Washington, DC: National Endowment for the Arts, 1993.

Saguaro Seminar, "Better Together: Report of the Saguaro Seminar—Civic Engagement in America," http://www.bettertogether.org/bt_report.pdf, n.d. Also see http://www.ksg.harvard.edu/saguaro/ for the Saguaro Seminar's general Website.

Sampson, Robert J., Stephen W. Raudenbush, and Felton Earls, "Neighborhoods and Violent Crime: A Multilevel Study of Collective Efficacy," *Science,* 277:918–924, 1997.

Schmitt, Bernd, *Experiential Marketing,* New York: The Free Press, 1999.

Schuster, J. Mark, *The Audience for American Art Museums*, NEA Research Division Report No. 23, Washington, DC: National Endowment for the Arts, 1991.

Scitovsky, Tibor, *The Joyless Economy*, New York: Oxford University Press, 1992.

Seaman, Bruce A., "Arts Impact Studies: A Fashionable Excess," in Gigi Bradford, Michael Gary, and Glenn Wallach (eds.), *The Politics of Culture*, New York: The New Press, 2000.

————, "The Supply Constraint Problem in Economic Impact Analysis: An Arts/Sports Disparity," paper prepared for Lasting Effects: Assessing the Future of Economic Impact Analysis Conference, Tarrytown, NY, May 2004.

Shusterman, Richard, *Pragmatic Aesthetics: Living Beauty, Rethinking Art*, 2nd edition, Lanham, MD: Rowman & Littlefield Publishers, Inc., 2002.

Stebbins, Robert, *Amateurs, Professionals, and Serious Leisure*, Montreal: McGill-Queens University Press, 1992.

Stecker, Robert, *ArtWorks: Definition, Meaning, Value*, University Park, PA: Pennsylvania State University Press, 1997.

Stern, Mark J., "Arts, Culture, and Quality of Life," Social Impacts of the Arts Project (SIAP), 2000.

Stern, Mark J., and Susan C. Seifert, "Re-Presenting the City: Arts, Culture, and Diversity in Philadelphia," in Gigi Bradford, Michael Gary, and Glenn Wallach (eds.), *The Politics of Culture*, New York: The New Press, 2000.

Stigler, George J., and Gary S. Becker, "DeGustibus Non Est Disputandum," *American Economic Review*, 67(2):76–90, 1977.

Stone, Ann, et al., *The Arts and Prosocial Impact Study: Program Characteristics and Prosocial Effects*, Santa Monica, CA: RAND Corporation, 1999.

————, *The Arts and Prosocial Impact Study: An Examination of Best Practices*, Santa Monica, CA: RAND Corporation, 1997.

Strom, Elizabeth, *Strengthening Communities Through Culture*, Washington, DC: The Center for Arts and Culture, 2001.

————, "Let's Put on a Show: Performing Arts and Urban Revitalization in Newark," *Journal of Urban Affairs*, 21(4): 423–435, 1999.

Survey of Public Participation in the Arts (SPPA), Washington, DC: National Endowment for the Arts, 1982.

Taylor, Charles, *Sources of the Self: The Making of the Modern Identity*, Cambridge, MA: Harvard University Press, 1989.

Thompson, Eric, Mark Berger, Glenn Bloomquist, and Steve Allen, "Valuing the Arts: A Contingent Valuation Approach," University of Kentucky Working Paper, 2001.

Throsby, C. David, "Assessing the Impacts of a Cultural Industry," paper prepared for Lasting Effects: Assessing the Future of Economic Impact Analysis Conference, Tarrytown, NY, May 2004.

————, "Determining the Value of Cultural Goods: How Much (or How Little) Does Contingent Valuation Tell Us?" *Journal of Cultural Economics*, 27:275–285, 2003.

————, "The Measurement of Willingness-to-Pay for Mixed Goods," *Oxford Bulletin of Economics and Statistics*, 46(4):279–289, 1984.

————, "Social and Economic Benefits from Regional Investment in Arts Facilities: Theory and Application," *Journal of Cultural Economics*, 6:1–14, June 1982.

Throsby, C. David, and G.A. Withers, "Measuring the Demand for the Arts as a Public Good: Theory and Empirical Results," in William S. Hendon and James L. Shanahan (eds.), *Economics of Cultural Decision*, Cambridge, MA: Abt Books, 1983.

Trilling, Lionel, *The Liberal Imagination: Essays on Literature and Society*, Garden City, NY: Anchor Books Edition, Doubleday and Co., 1953.

Underhill, Pace, *Why We Buy: The Science of Shopping*, New York: Simon and Schuster, 1999.

U.S. Department of Education, "Adult Education Participation Decisions and Barriers: Review of Conceptual Frameworks and Empirical Studies," National Center for Education Statistics, Working Paper No. 98-10, August 1998.

Verghese, Joe, Richard B. Lipton, Mindy J. Katz, Charles B. Hall, Carol A. Derby, Gail Kuslansky, Anne F. Ambrose, Martin Sliwinski, and Herman Buschke, "Leisure Activities and the Risk of Dementia in the Elderly," *New England Journal of Medicine*, 348:2508(16), June 2003.

Wali, Alaka, Rebecca Severson, and Mario Longoni, *The Informal Arts: Finding Cohesion, Capacity and Other Cultural Benefits in Unexpected Places*, Chicago, IL: The Chicago Center for Arts Policy at Columbia College, 2002.

Wallis, Allan D., "Toward a Paradigm of Community-Making," *National Civic Review*, 85:34–47, Winter 1996.

Walton, Kendall L., "How Marvelous! Toward a Theory of Aesthetic Value," *The Journal of Aesthetics and Art Criticism*, 51:3, Summer 1993, pp. 499–510.

Weinstein, Arnold, *A Scream Goes Through the House: What Literature Teaches Us About Life*, New York: Random House, 2003.

Weitz, Judith H., *Coming Up Taller*, Washington, DC: President's Committee on the Arts and the Humanities, 1996.

Welch, Nancy, *Schools, Communities, and the Arts: A Research Compendium*, 1995.

Welty, Eudora, *On Writing* [1942], New York: Modern Library Edition, 2002.

Whitt, Allen J., "Mozart in the Metropolis: The Arts Coalition and the Urban Growth Machine," *Urban Affairs Quarterly*, 23:15–36, 1987.

Wilson, Robert S., Carlos F. Mendes de Leon, Lisa L. Barnes, Julie A. Schneider, Julia L. Bienias, Denis A. Evans, and David A. Bennett, "Participation in Cognitively Stimulating Activities and Risk of Incident Alzheimer Disease," *Journal of the American Medical Association*, 287(6):742(48), February 2002.

Winner, Ellen, and Lois Hetland, "The Arts in Education: Evaluating the Evidence for a Causal Link," *Journal of Aesthetic Education*, 34(3–4), Fall/Winter 2000.

Winston, Andrew S., and Gerald C. Cupchick, "The Evaluation of High Art and Popular Art by Naïve and Experienced Viewers," *Visual Arts Research*, 18:1–14, 1992.

Wolff, Thomas, "Community Coalition Building—Contemporary Practice and Research," *American Journal of Community Psychology*, 29(2):165–172, 2001.

World Bank Website on Social Capital, http://lnweb18.worldbank.org/ESSD/sdvext.nsf/09ByDocName/SocialCapital.

Yoshitomi, Gerald D., *Engage Now! An Arts Worker's Guide to Deepening Experience and Strengthening Participation in the Arts,* Heinz Endowments, 2002.

Zaltman, Gerald, et al., *Understanding Peoples' Thoughts and Feelings About the Arts*, prepared for the Howard Heinz Endowment, Pittsburgh, PA, 1998.

Zimmerman, Barry J., "Self-Efficacy and Educational Development," in Albert Bandura (ed.), *Self-Efficacy in Changing Societies*, Cambridge, UK: Cambridge University Press, pp. 202–231, 1995.